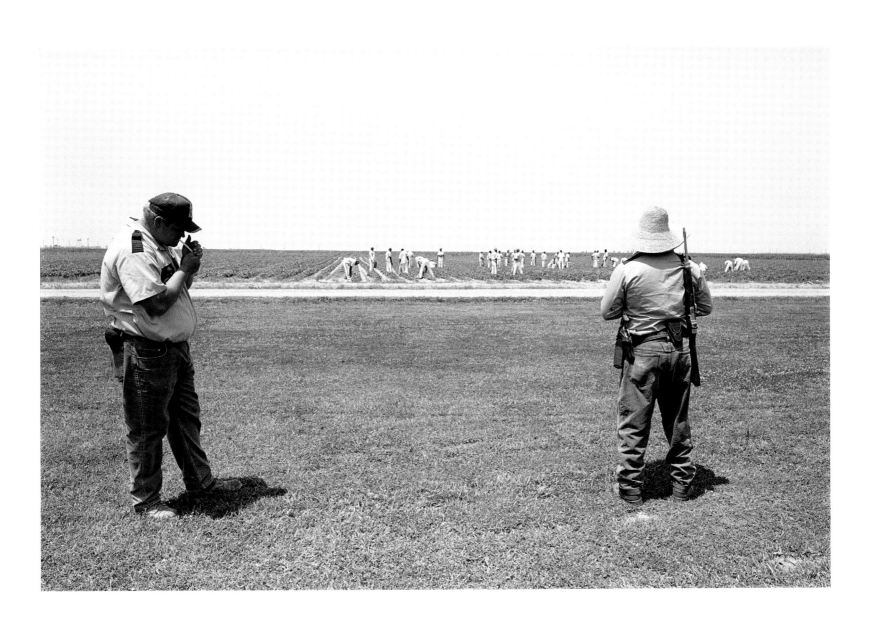

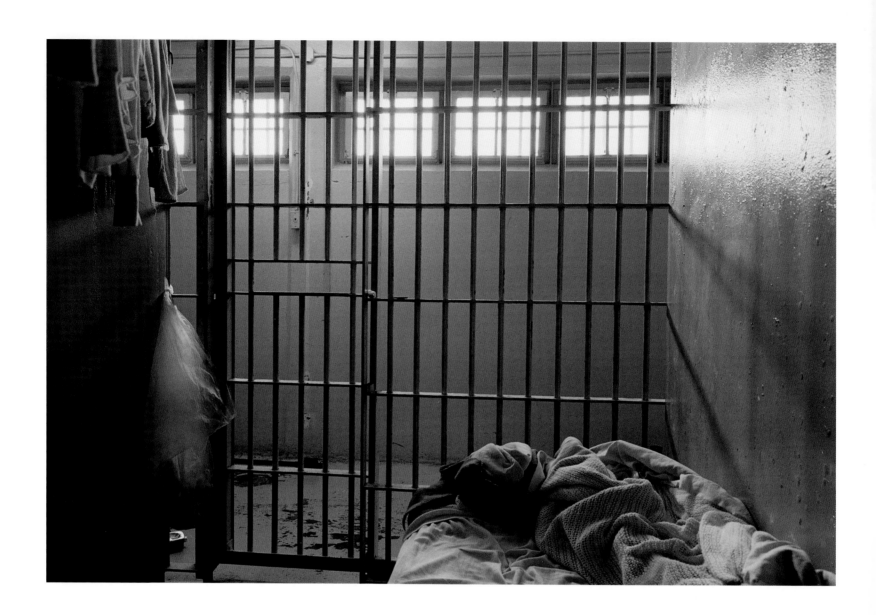

PARCHMAN

R. Kim Rushing

Foreword by Mark Goodman

University Press of Mississippi Jackson

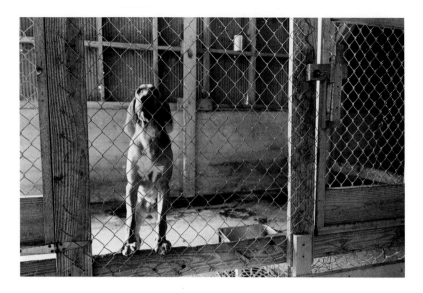

To Dorothy Shawhan, a great and thoughtful lady

www.upress.state.ms.us

The University Press of Mississippi is a member of the Association of American University Presses.

All photos courtesy of the author.

Page 1: **Field workers with guards.**

Page 2: **Larry Washington's cell from inside.**

First printing 2016

Library of Congress Cataloging-in-Publication Data

Names: Rushing, Kim, writer of preface, photographer. | Goodman, Mark
(Professor of communications), writer of foreword.

Title: Parchman / R. Kim Rushing ; foreword by Mark Goodman.

Description: Jackson : University Press of Mississippi, [2016]

Identifiers: LCCN 2015040284 (print) | LCCN 2015044825 (ebook) | ISBN
9781496806512 (cloth : alk. paper) | ISBN 9781496806529 (ebook)

Subjects: LCSH: Prisoners—Mississippi—portraits. | Mississippi State
Penitentiary—Pictorial works. | Imprisonment—Mississippi—-Parchman.

Classification: LCC TR681.P69 R87 2016 (print) | LCC TR681.P69 (ebook) | DDC
779/.9365609762—dc23

LC record available at http://lccn.loc.gov/2015040284

British Library Cataloging-in-Publication Data available

Wire and Walls

Mark Goodman

Do not despair; one of the thieves was saved.
Do not presume; one of the thieves was damned.
—St. Augustine

I was suspicious of the police as a child, even in the sleepy 1950s, a time when the popular media portrayed policemen as friendly and helpful to children. However, I knew one or two things more. My father's contempt for the cops was always apparent; every time he'd eyeball one while driving, he'd swear under his breath, or out loud if the windows were rolled up.

One evening when I was six years old, a uniformed policeman appeared at our door selling tickets to the annual Policeman's Ball. My father quickly turned him away, but he returned about an hour later to try a different sales pitch. Leaning against the doorjamb, seeing me seated on the staircase, he said to my father: "You have a son. You never know what trouble he'll get into. Or when. But he will, sooner or later." My father was not intimidated, and the officer sold no tickets at our house. But from then on, I believed the law had its eye on me, waiting for me to commit some wrongdoing (as my father did in his youth), and I joined him in a mutual mistrust of uniformed men with badges and batons.

For the rest of my childhood, whenever we'd drive near the cemetery—the one with the stone statue of the soldier forever blowing taps on a bugle—I knew we were nearing the police station. I'd crouch down in the well of the backseat of the car and peer through the window above as electric power lines and tree branches moved across the sky until finally, after what felt like an eternity but could only have been a few minutes, I saw the rooftop of the police station recede in the distance. Safety once again.

I knew I'd done nothing wrong, but since the law was thinking about me and had stood in my own doorway and told me so, I couldn't be too careful. I never did get into trouble back then, as a child or even a teenager, never wanting to dance around with that cop, or any other. And I've never even been in jail as a visitor, seeing it only in the movies and in photographs and in a fearful place in my heart.

Kim Rushing is a photographer who never served prison time either, though when it comes to cops and convicts, he has more courage and curiosity than I have. For several years, he lived in Ruleville, Mississippi, twelve miles down the road from the famous (some say notorious) Parchman Penitentiary. Kim, a Mississippian born and raised, decided in 1994 to ask permission to photograph around the prison grounds—the landscape, the ex-

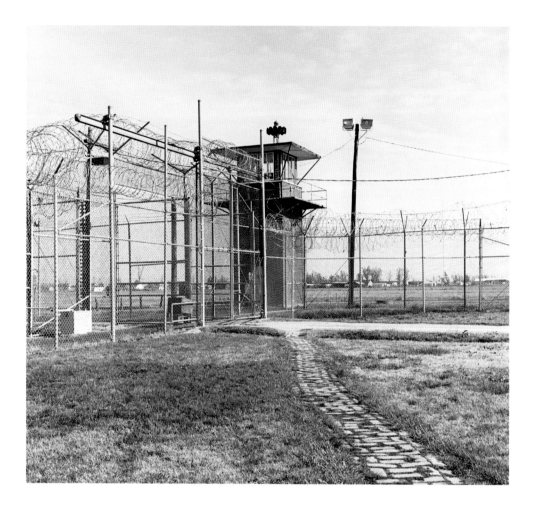

teriors of the buildings, and the guard towers. To his surprise, his request was granted; the assistant superintendent had heard of him, though not as a photographer. The reputation that preceded him to Parchman was that of a courageous citizen who thwarted a criminal:

"It seems that [the assistant superintendent] heard about me catching a Peeping Tom out in my front yard. I waited for him one night with a pistol my daddy had given me and when I caught him, I told him to please move on away from the window. When he tried to run away, I fired the pistol into the grass in the front yard; it scared him so bad he fell down and shit in his pants. The assistant superintendent had heard this story, knew my name, and said, 'You're the guy that tackled Big Nasty and held him down until the police could get there, right?' Of course, I didn't ruin my reputation by saying, 'No, I had a pistol.' I just said, 'Yeah, that's me.'"

For the first six months, Kim photographed anything he wanted except inmates, on the grounds outside the gray walls of Parchman, a prison composed of more than two dozen building complexes. Then he revisited the assistant superintendent to ask if he might enter the gate and take pictures of the prisoners inside. He wanted to see for himself what, if anything, he'd heard about life at Parchman was true. Were the inmates constantly

assaulted, or did they have it made? Were the prisoners subjected to rape by other convicts and beatings by the guards, or did they just sit around in air-conditioned buildings, watch cable T. V., and eat three meals a day—paid for by the state—paid for by the taxpayers? Was prison life in Parchman hard or easy, or both? Perhaps in part to counter the myth that places like Parchman were either pleasant (if dull) resorts or out-of-control living hells, as well as the growing public perception that Parchman was corrupt and mismanaged, prison officials agreed to let Kim inside. He was the first outside photographer in Parchman's history to photograph inmates; eighteen men volunteered to share their cells and stories with Kim, and with us.

The Mississippi State Penitentiary at Parchman covers twenty thousand acres (forty-six square miles) in the heart of the Yazoo Delta, one hundred miles south of Memphis and ninety miles north of Jackson, between the Sunflower River and Highway 49 in Sunflower County. It was constructed in 1904; designed like a private plantation, it was built without walls or guard towers. Only a few strands of barbed wire surrounded the central field camps where the black male prisoners, dressed in circular striped uniforms, did field work in the service of King Cotton, the state, and the local growers who leased sixty-five percent of the land. (White prisoners were sent to segregated camps at Parchman beginning in 1915.) If working the cotton fields at Parchman was a servitude similar to what black men experienced elsewhere in rural Mississippi at the time, it was at least a change from their being tortured and lynched on the spot in their home counties when accused or convicted of a crime. Except during the low point of the Great Depression, Parchman Farm, as it was then known, always turned a profit.

In 1954 the prison walls went up with the construction of the first maximum security unit. Reforms ordered by the courts in 1972 led to the creation of the Mississippi Department of Corrections four years later; this inaugurated the use of paid civilian guards overseeing the 2,500 prisoners, desegregation of the inmate population, and subsequently the beginning of the pervasive reign of terror and warfare by both black and white inmate gangs. All these changes, plus the addition of four guard towers, double razor wire fences, electric gates, and 1,000 new individual maximum security cells in the early 1990s, completed the transformation of Parchman from a plantation to a penal colony.

As of this writing, the entry gate to the prison consists of four I-beams painted with alternating white and gray stripes. Nearby are three signs: "Stop"—"20mph"—"Coke is it." There are no signs with messages for incoming prisoners, no admonitions, nothing like "abandon hope all who enter here," or "work will set you free."

Architecturally the prison is defined by two-story rectangular buildings that resemble nothing more than boxes marked off on graph paper; each monotonous box appears like a plain package, filled with secrets.

If the light of the Mississippi Delta is harsh and relentless, and the air is humid and mosquito-ridden, inside the prison the sunlight (at least in these photographs) glows and ricochets off the cell bars and walls, casting shadows suggestive of daydreams. But the

fluorescent lights wash out illusions, revealing the institutional flatness and the bareness of the hard facts boxing the prisoners into their circumscribed world.

There are television sets in the medium security barracks—the "cage"—with rabbit ears, no cable connections. They only pick up two stations and that's on a good day. Prisoners in these units spend most of their days sleeping, killing time, or getting into trouble; they do leave for meals and work details where they may be assigned jobs in field and house operations (pulling weeds by hand, washing the walls, cooking in the kitchen, passing out uniforms) or in one of the prison industry programs (making garments, wooden signs, janitorial supplies, gloves, saddles or working in metal fabrication and printing). Cotton is no longer the sole profitable product. Aside from that, there are iron weights to pump at gym call (one hour, twice a week) and some education classes, though most of these were discontinued in 1995 when getting tough on crime got tougher still. There is no air conditioning; electric fans move the heavy air unless the plug is pulled for disciplinary reasons. As inmate Marty Montgomery, sentenced to twenty-five years for robbery, said: "Life in Parchman isn't nice or comfortable, but then, it's not supposed to be. Winters are cold and you bake in the summer; it it's 95 degrees outside, it's over 100 degrees in the dorm with no air circulation," not to mention "the bad food, the deafening noise, and the rampant stupidity."

Prison is a place not so much for accountability, as it is for counting. The prisoners are constantly counting their time left to serve—ticking off the days, weeks, months, and years—minus time off for good behavior. And there is a counting of another kind, a mental one that transforms the physical reality of the place back into a graph paper diagram. When Terry Wilkins was sentenced for breaking and entering, he was sent to Parchman and immediately began counting. First, the number of white prisoners in his zone: "only seven, counting myself"—then the bathroom fixtures: "two mirrors and three toilets and two sinks under the two mirrors"—and finally the contents of the commons area: "a T. V., two benches, and three tables that each had four places to sit." Three months later, he was moved into a dormitory where there were: eighty-five beds and lockers in rows, one bathroom with six toilets and six sinks, and one three-person shower. After these items are inventoried, there is the more obsessive counting of: cinder blocks—how many make up a cell wall?, linoleum squares—how many make up a cell floor?, steel bars, vertical and horizontal—how many make up a cell door?

And the prisoners themselves are counted by the guards while prison administrators and state legislators count dollars and percentages. In 1996, according to Mississippi Legislature Report #346, the average cost per inmate per day was $38.08. Basic housing accounted for nearly half of that amount—$20.55—while food at $1.22, education and training at $1.89, and medical at $4.01 added up to less than the $7.57 paid for interest on money borrowed to construct the state's only major prison.

In the January 30, 1995, "Summary Report: Investigation of Certain Operations in the Mississippi Prison System," the state auditor found that forty-seven percent of the inmates

have a history of substance abuse. Of the 3,479 new prison admissions between January 1 and October 5, 1994, thirty percent were sentenced directly for drug convictions, while it is estimated that an additional thirty percent of the convictions involved drugs as the underlying cause. A large percentage of the daily medical cost is for the one-of-three prescribed narcotic drugs that 1,600 to 1,700 inmates regularly take every day, or due to the frequent theft of the remaining narcotic drugs from the prison hospital.

The convicts sometimes refer to the prison by its name—Parchman—the geographical place where they're located. But more often, they simply talk about the System—shorthand for the abstract place where they're stuck and from which they're attempting to extricate themselves, though of those who manage to be released, forty-nine percent return.

Many inmates believe that their redemption, or at least their release, rests solely on their shoulders. They don't see Parchman or the System as attempting to accomplish anything more than retribution—not rehabilitation, which most of the public believes is futile. Gregory Applewhite, convicted of homicide, defiantly thinks that in prison, you're pressured to become institutionalized, a cipher, to stop being your own man. Gregory admits he made a mistake, and did so again. While incarcerated, he murdered another inmate, though he quickly adds, "I'm still a man!" and, by implication, not a number.

Other prisoners feel that the way to get out is to fit in, or at least to appear that way. One inmate Kim photographed pretended contrition while in front of the camera, hoping to send a humble-looking portrait to the district attorney who had convicted him, foolishly thinking he would convince him with faked feelings that he had learned his lesson.

Willie Lamb, convicted of robbery, believes it's not enough for him to adopt the look of being reformed, but tries to convince the authorities that he is truly striving for a change and that after he is released, he will actually "outshine the average person."

Gregory, sentenced to life, offers a detailed fantasy of himself after prison: "Get married. Find me a job. I want a whole house of kids. Leave the street corners alone. Leave the juke joints alone. And—go to church."

As we look at these photographs of men convicted of various felonies—homicide, robbery, burglary, drug sales, simple and aggravated assault—we do not see their crimes visible on their faces. This one killed, that one stole—it isn't there. Neither do we see their innocence on their faces. These men are closed, holding still, cautious. As they face Kim, who is facing them, they are sizing up Kim, who is sizing them up. Looking at their pictures, we stare into their eyes as they stare into the lens of the camera. Willie Lamb never used to tolerate being stared at: "Before I came to Parchman no one could look at me for more than twenty seconds, or I took it as an invitation to fight." Who you looking at? As with Travis Bickle on the edge of violence in Scorsese's film Taxi Driver, "You looking at ME?" is both a question and a challenge.

The men we see in these photographs are pinned between boredom and anxiety—the boredom of nothing happening and the anxiety that something will happen, something bad, usually violent. They stare off into space, some spiraling deep inside their minds

like Terry Wilkins who says his nerves "got real bad" until finally, by order of a prison doctor, he was moved to a private 10 x 10 foot cell, a place where "time starts doing you." Others appear to magically escape into the air like Gregory Applewhite, poised on tiptoes atop his mattress folded in half, gazing like a Peeping Tom through his one window into the world outside, seeming to float on the prison air. If man could fly, Gregory would launch himself off his thin mattress, out of his cell and into the light beyond.

Whether we voluntarily exile ourselves to new and unknown towns and countries, or we've been sent to prison by the state for our crimes, photographs from home remind us of what we've lost and what we imagine we hope to retrieve. But whatever that may be, it's never the same as when we left, and we're not the same anymore, either. If thoughts of home keep some inmates going, for others they bring on a resigned hopelessness.

When Terry Wilkins first entered Parchman, he created a wall of snapshots showing his three daughters seated on a pony, on a swing, on his lap; these pictures were neatly lined up. Taped onto blank pieces of paper which covered the cinder blocks, they were accented with two press-on bows in the middle of the wall. This was the wall of innocence—little girls, pink ribbons and bows. Two years later, after being stabbed seven times in his leg by another prisoner wielding a shank, he was moved for protection, at his own request, into a maximum security cell.

"I went to my cell and unpacked and shut my door and went to sleep. After a few hours of sleep, I got up and washed all my walls and floors. My bed was made of steel and my mat was one inch thick; it was just like sleeping of the floor. I had my own mirror and toilet. I also had a button to push to open my door whenever I wanted to come out. I was only there a few hours when this white convict asked me for a smoke. I gave it to him and he was gone. In one minute he came back and asked me for a shot of coffee. I gave it to him and he was gone again. Then the next thing I saw, he cut his neck with a razor. Blood was everywhere."

In this new, safer cell, Terry stares at glaring bare walls. Are the snapshots memorized, or are they now too painful to see? Did they suddenly become mementoes of a man who no longer exists, except in name and number only? After years of confinement, where the days run together with no clear demarcation, each one the same as the one before and after, Terry awaits the luck of the draw with the parole board. Not counting on their goodness and mercy to set him free from the shackle-and-chain dance in the House of the Dead, instead he invokes an incantation:

"Parchman is the Heart of Hell!
Parchman is the Heart of Death!
Parchman is the Heart of Drugs!
Parchman is the Heart of Nation against Nation!
Good bye Parchman. I leave in December, flat-time."

Preface

These photographs are a result of my desire to know more about the way other people live their lives. It's that sense of curiosity that has kept me making images for many years now. I lived in Austin, Texas, from 1986 to 1989 and was making a lot of photographs there. That was where I discovered that making photographs is what I do to experience something I am curious about. Hyde Park, the oldest neighborhood in Austin, was a short distance from my house. I went there several times a week for several months and walked from end to end, and side to side, with my camera and my wife, Mollie. We met people and had conversations about the size of the pecans that year, how well the trees produced, and if the flavor was as good as last year's crop. We learned a lot about pecans that fall. I learned a lot about image making.

I had bought a secondhand Mamiya C-330 TLR and fallen in love with it. It was a big, bulky camera, but it was quiet and I didn't have to put it in front of my face to make a picture. The more I used it, the more its use became second nature. I didn't have to interrupt a conversation to change film and certainly not to adjust my exposure. I'm not sure if the people I met were aware I was making their pictures until after the fact, when I told them. I always told them. There are too many things in this world to photograph without making a picture of someone who would rather you did not. My most successful photos were simple, straightforward portraits of people at peace in their yards, with unguarded faces and open gestures.

At some point I discovered the Texas-Mexico border towns that were just a few hours south of Austin. I had spent most of my life in small-town Mississippi. The border towns were exotic places, full of strange people and strange ways. I found that the newness of the place wore off pretty quickly and what was left were the people. Border towns had a culture mostly unfamiliar to me, more Mexican than American. Mollie and I went to Nuevo Laredo a lot and for a long time. We went to the same places over and over and became known to some extent, enough so that people didn't notice us as much. It was my curiosity about the culture that attracted me there, although, once I was there, I became a street photographer. I created fictitious little narratives with my camera. If I placed the edges of my camera frame around a small nonevent, and the light was right, and I snapped the shutter at the right moment, something exciting happened. Oftentimes, I knew when I tripped the shutter if I had something significant on film. It was very satisfying.

Near the end of our time in Austin, Mollie and I were sitting on the back steps of our house drinking coffee as we did most mornings. This particular morning Mollie brought a map of the United States with us and she asked me a question. "If you could go anywhere in the world to photograph, where would you go?" My answer was surprising even to me

because I said Tylertown, Mississippi, and Walthall County. The answer came out of my mouth before I had time to think about it. At that precise moment, bird poop from a passing bird landed near Tylertown, Mississippi, on the map that was spread out in our laps. It was definitely a sign. I was born in Tylertown and had lived the biggest part of my life there. It was the place I knew the most about and, as I came to discover, the place that was the most difficult for me to see.

Mollie and I grabbed our tent and our cook stove, my cameras, and our coolest clothes, and went to Walthall County for the summer. We mostly visited friends and family and made pictures. I borrowed the darkroom at the office of the Tylertown Times to develop film and make some prints. I found that while the film was exposed perfectly, and the prints were technically correct, the images were just not interesting. I could not see what was causing the problem, but Mollie could. There I was photographing friends and family. Everywhere else I worked, the things in front of my camera were all potential subject matter with which to make a photograph. I wasn't able to separate myself from my knowledge of, and my relationships with, my friends and family. I left myself no room to discover anything new—what a valuable lesson.

It became clear that it was time to limit my field of view, and I found I needed help. The path to that help came from my past. I had become interested in making photographs because of the images I saw in my hometown newspaper. Each week the Tylertown Times ran an article featuring the past. The story told of an event that took place seventy-five years ago that week. It included a photograph to show us what it looked like. Then they would pin the actual print on a board on the sidewalk just outside of the office. I had never been so excited by such a small thing.

That awareness, and a suggestion from Mollie, sent me to meet with Patti Carr Black at the Mississippi Department of Archives and History in Jackson, Mississippi. I asked her to suggest a subject near Tylertown that would be useful to the collection of the museum. She directed me to dairy farmers and truck farmers. I had my subject to keep me working for the next year. That year, making pictures in my home place turned out to be as much about getting to know myself as it was about image making. One of the most valuable things I learned was this: the place that I came from was at least as significant as all of the places I dreamed of going.

When we left Austin, it would have been nice to come back to Mississippi, but it wasn't time yet. We moved to an ancient farmhouse in the woods outside of Weaverville, North Carolina. There I continued to work by finding a small group of people living in an unfamiliar way. We spent a season with two tobacco farming families in Ballard Cove. Mollie was there with me again working the tobacco. She planted, and picked, and she hung tobacco in the barn to dry. I made pictures and we got to know the Ballards.

At some point I started working on getting back to Mississippi to live. Every few months I would get on the phone and call every college and university in the state. The question was always, "Do you need someone to teach photography yet?" In 1992 no school

in Mississippi offered a BFA with an emphasis in photography. I believed one needed to do so. Delta State University was the first to give me the answer I was looking for. Tom Rankin was leaving his position in the art department and suggested I apply to teach photography there. The decision to move to the Mississippi Delta fell into my lap. We landed in Ruleville, Mississippi, a very small town in the heart of the Delta. There I came face to face with the influence Parchman Penitentiary has on the region.

I felt a connection with Parchman from my childhood. My father was a special deputy in Walthall County, Mississippi. He often transported prisoners from the county jail to Parchman to begin serving their time. I was quite curious about the prison. I didn't know it was such a mysterious place and that others were curious about it as well. After becoming known in the area, I was allowed to photograph eighteen inmates for almost four years. These men allowed me to visit with them and photograph them in their personal space and during their daily activities.

In all of my previous work, I had been able to photograph in a spontaneous way. At times, something would appear in front of me and I would make all the decisions necessary to trip the shutter in a small part of a second. I liked it when everything was in flux—the subject, the light, the camera and me, constantly changing. Inside Parchman, things changed at a much slower pace. The light was constant and low. I was often forced to use a half-second exposure. I studied my subjects and they were not moving very much. Once more, my subject was studying me. There was a tripod involved. This was a whole new way to make images and I was quite comfortable with the old way. The thing that had not changed was my curiosity. My camera helped me understand.

When I started this work I was interested in the mysterious culture of a prison community. One of the most interesting aspects of the work is being able to see the visible change, or lack of change, that becomes obvious when viewing portraits of the same prisoner made years apart. I find those images exciting. I would like to claim that with this work I am picking a fight with gang violence, or the decisions made concerning race in our prison system, or any of the large number of problems resulting from putting people in prison. My real interest is more selfish. What is it like to be an inmate in Parchman Penitentiary? What happens to an individual there? How does it happen? How do the prisoners feel about their circumstances? I hope others can use the work I do for more lofty purposes. I feel okay providing them with information.

Acknowledgments

Thanks to Ed Hargett and Lynn Warren for getting me permission, Chief Charles "Chubby" Winters for going with me every day, Anna and Donny Caffey for always being interested and available, Keith Pettway for asking and never forgetting. I am most grateful to Mollie Rollins Rushing for paying attention and speaking up.

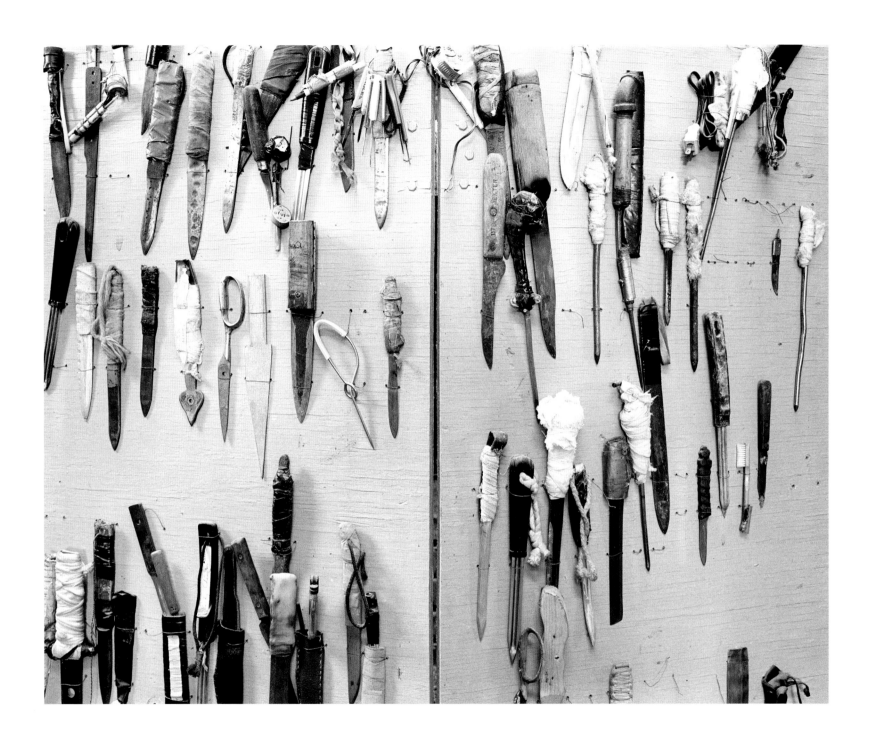

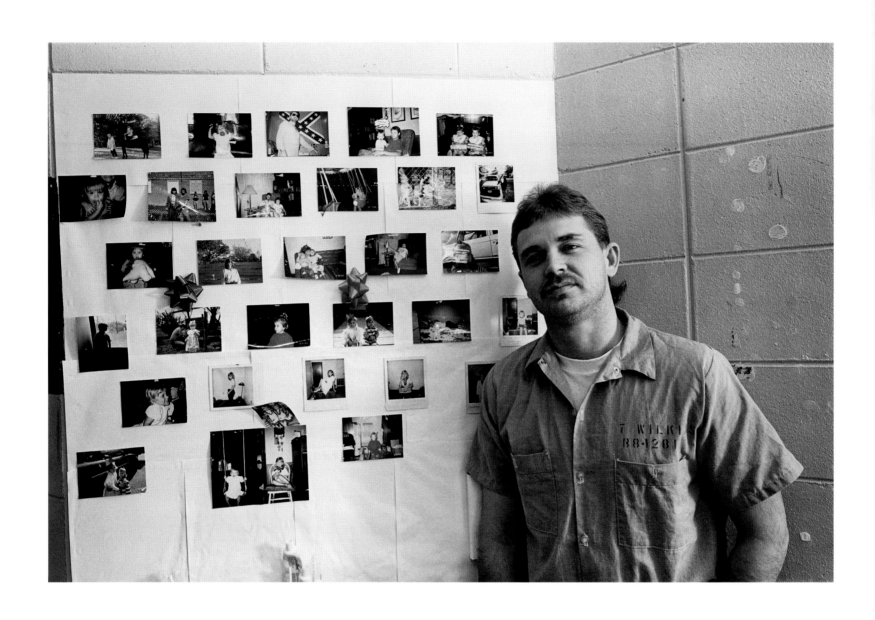

16 Terry Wilkins with photographs, 1994.

April 8th 94

(Life in the state Penitentiary)

Greetings my name is #B-84281, in the Gray Walls of Parchman, But the Inmates call me Hollywood. Because of the Aurthor of this Book (Kim Rushing) He has came to me infront of the Inmates and Convicts, And took many Pictures of me over the past Two years. They all wish they could be in my Spot Lights. They only get to Set back and Watch. After Mr. Kim Rushing Packs away his Lights and Cameras and he Walks away to the Free World. The Inmates and Convicts ask me many Questions. I tell them all that I'm writing Aspects of my Life in Parchman. And Present it to the Free World in the form of a book. My intentions are not to use my Writing to Confront Political issues. Just my Life in the State Penitentiary. Shall we began..

The Blue Bird (Bus) Pulled in the gates of Prison Mid-day April 1994 very hot. The bus took the Crue of 38 Scared Inmates with hair So Short the Sun

pg two

Would blister your scalp within 30 minute's out in it. The bus went straight to the Hospital (Camp 42) The K-9 took all the shakles off the hands and feet of all the Scared Inmates Even I was troubled but not scared like all the young guys I was 29 at the time. And then after a few hours past, the old Parchman bus drove up with a convict setting behind the wheel. Inmates were in the holding cell of the Hospital over 75 or more. Saying rude things to us new Inmates. As we wated on the Transfere officer to get there. To take us to what ever camp we was going to. I went to Camp 29-7 building It looked like a camp in the deepest part of the Farm, which it was. I walked in the zone they told me to go in. They gave me a bed number which was a top bunk. Above a big 450lb man. white man. All togeather after I looked and counted the white people there were only seven counting myself. Then I layed on my Rack and went to sleep when I woke up every one was asleep.

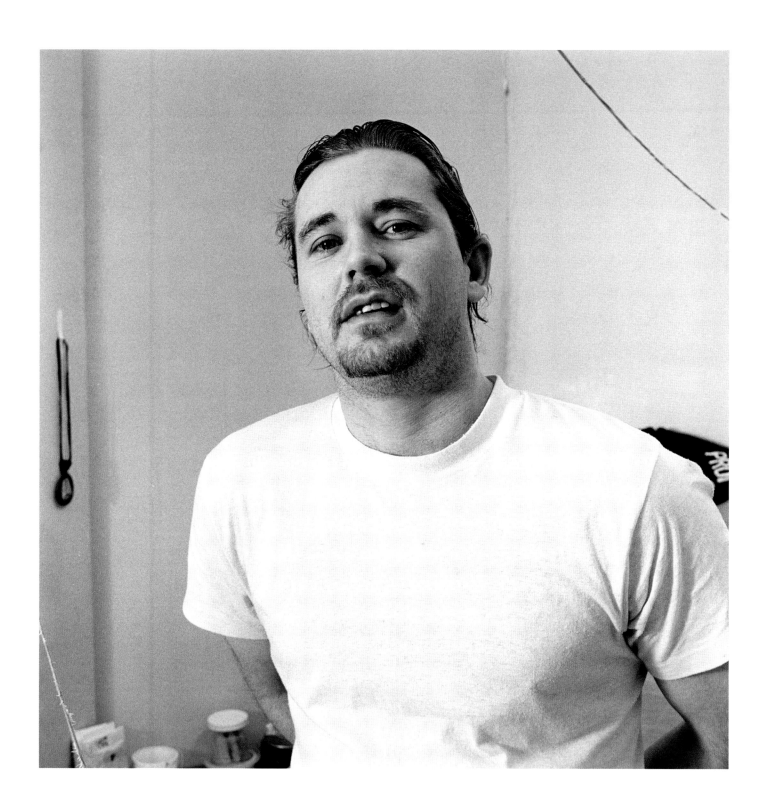

Terry Wilkins, 1996. **19**

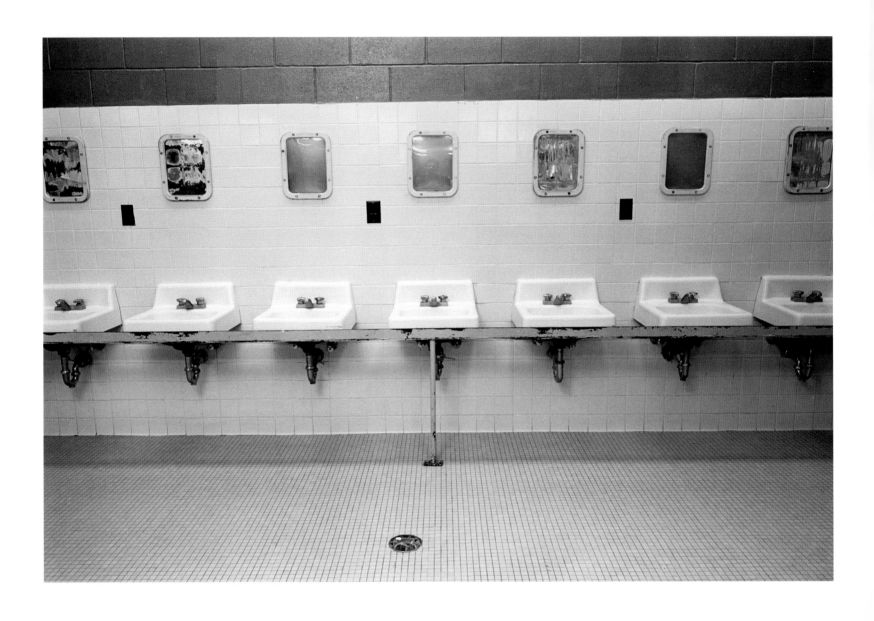

20 Wash facility.

I got up, and went to the Restroom, it was wide open So the officers in the tower could See. There was two mirror's and three toilets and 2 sinks under the two mirrors. I washed my face, then I looked around the Zone, and there was 4 beds in each (Q) and down on the First Floor there was a (TV) and 2 benches and 3 tables that had 4 Places to Set. It looked like the Zone would be. okay I went back to my Rack and slep until 5:00 AM They Called going back. I didn't Understand the saying. It donged on me) It's time to eat. It was still dark outside We walked over to the Kitchen and had a Seat. Until The table I was at was Asked to line up. It wasn't much of a Meal Everything on the tray could Feed a 3 year old Baby an be Full. You had to buy the extra Food you needed to get Full. Thats how the Kitchen worker Made there hustle. We only had 10 minute's to eat. We got back to the Zone. I just Set back and watched Each Convict and the New Inmates.

There Was groupes of convicts. the Vice-lords and The gansters and The Bloods and the Crips and the AB's. They are all against each other. I didn't speak to anyone, I Just Set and watched For over a week, to See how each Person carryed his·Self. There were Many Fights over the First Month I was there. One thing you don't do is watch the Fight, Because one of the brother's will come to you and try you. You See no Fight, you hear no Fight, and you Speak no Fight. I had Starting to talk to the one's That I Knew wasn't in any Gang. It really wasn't nothing to talk about only who are you and how much time you have. I Stayed there For 3 months, and I Signed up to go to School at Camp 30 "Bam" The Next day I was moved to Camp 30, I went to A-building There in the Zone I was Signed to was Nothing Like camp 29. There were Rolls of bed's and lockers and about 85 beds. There was a big bathroom Six toilets Six Sinks and one big shower For 3 people at a time

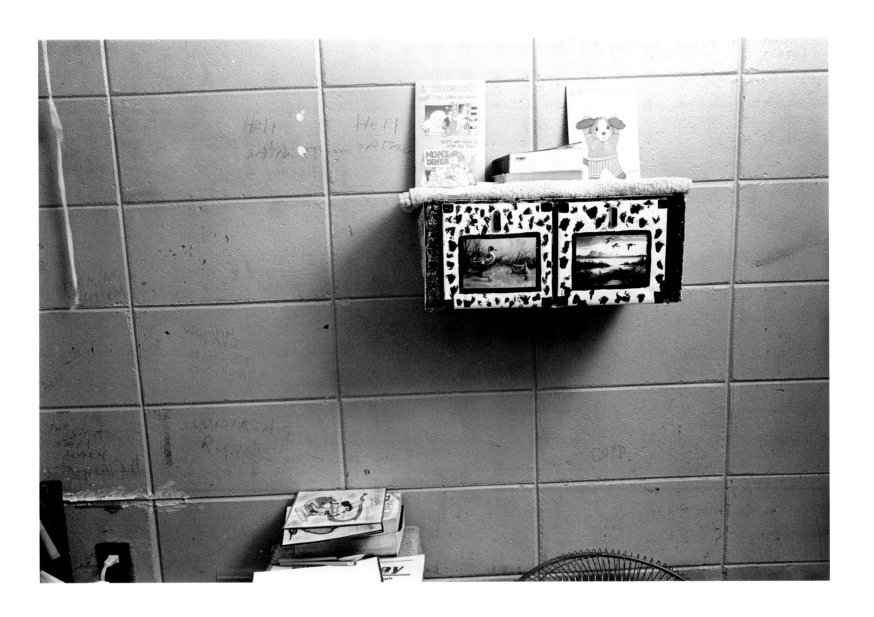

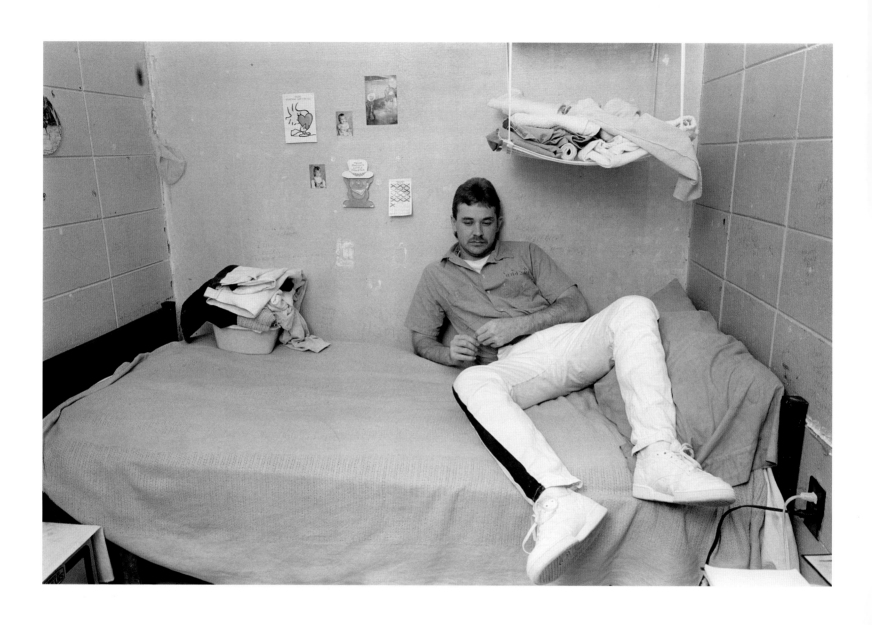

24 Terry Wilkins on bed, 1994.

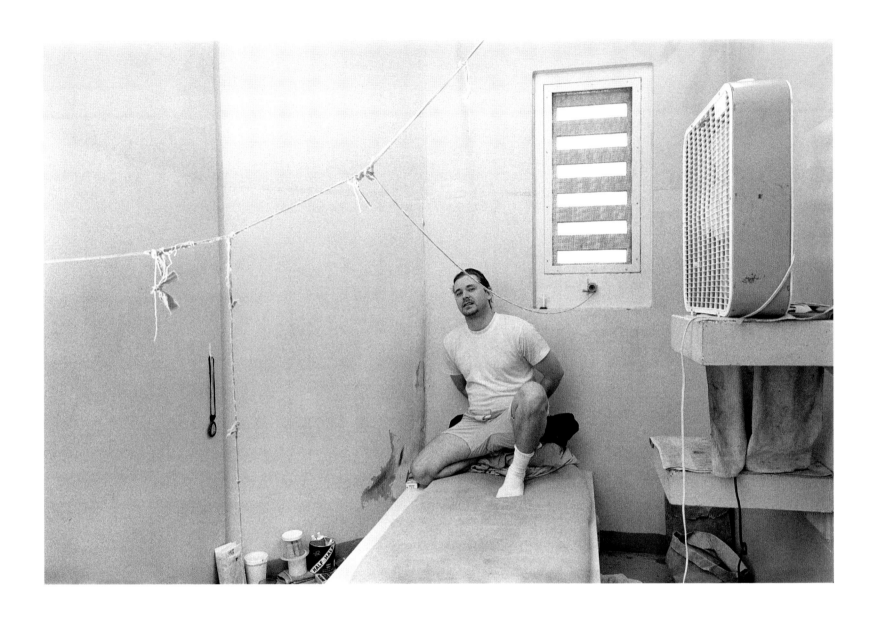

To take Showers. The First Week there it Wont alright, But there Were Stil gang-members. The next week it came a Storm and the Lights Went out. Then the Gansters and Vice Lords, Started walking around and around the Zone Straped with Shanks. The Officers would not even Come in to Count like they were ordered to do, They just Shined the Flash light through the tower windows every hour. That was the First time I got Scared. The night went on then I Could See a little of the gray Sky Morning Coming through the Small windows, After the months Past I Started to talk and know the names of the Convicts and Inmates, We had Gym Call twice a week only For an Hour, It had a basketball Court and alot of weights. I Started working Out each time we went there. And on Sundays We had Bible Study at the Gym, Very Few went to have Bible Study, The other's just went to be able to talk to their Brothers from the other buildings A, B, C, & D.

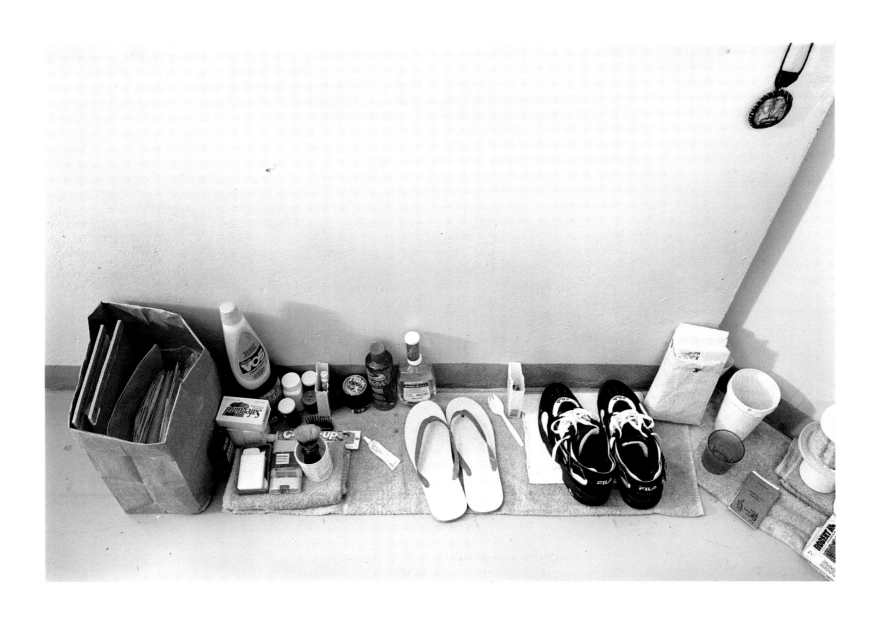

The First of June 94 Page 6

In June I got moved to D-building and started going to the Front School to inter Welding class, First I had to take a test on my Grade level. I past. So I started Welding class. the tool man gave me all of my tools that it would take For me to Weld. The Front School has alot of classes that you can chouse From (Auto Shop) (Body shop) and (Pluming Shop) (Machine shop) (Disel Shop) and (Kitchen School) (Electrical Shop)

The next day I started Welding, Hot was not the word in the middle of July up in a Small booth Welding For 6 hours Non stop useing 150 Rods a day 10 min For Lunch was the only break we could have. And when it was time to go back to the Camp, We all had to take our Shoes off and Surched From head to toe. After a Few months of Welding, I started metting other Inmates and Convicts From other Shops. I had this one Inmate that Would make me Rings out of brass and Stanless Steel, IF I Put the

brass on the Stanless Steel and grind it into the Shapes of a Ring, I had to slip and hide to be able to do those things. Sometimes It Would take a week to make 5 Rings and they would look like they Came From a Jewelry Store. I Could Sell them back at the camp to Inmates that wanted a Ring to give to there wife or other Family members. They were Sold for 3 and 4 Dollars, They were Worth more But this is Prison. I Welded on through July, Then I got down in my back, and I Stoped going to Class. And the time I was having to do. Was Starting to do me, my Nerves got real bad, I Went to the hospital and talked to Dr Russell at the psychiatrist Dept. He thought I needed to have my own Room, So he wrote up a Staff request for me to be moved to Camp 29 under Special Needs A and B building, He Started giving me Ativan For my Nerve Problem's It Helped alot.

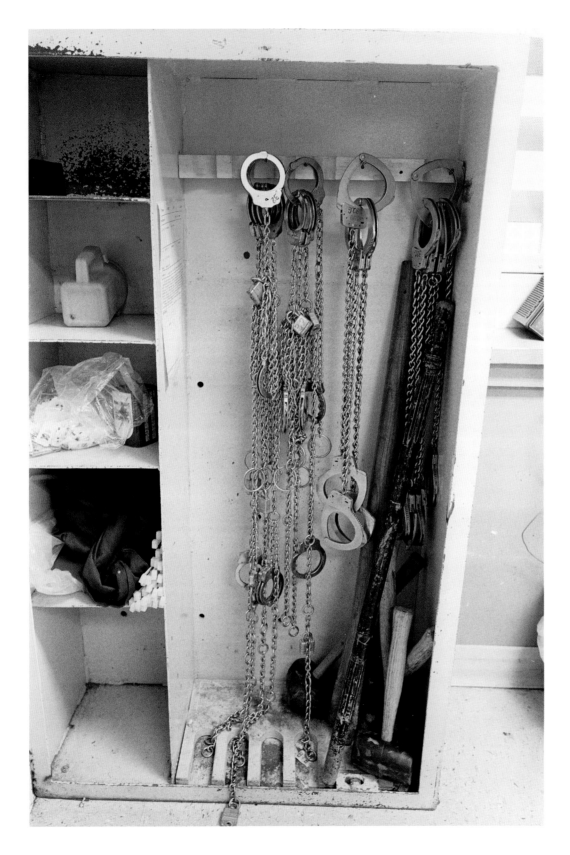

30 Restraint gear.

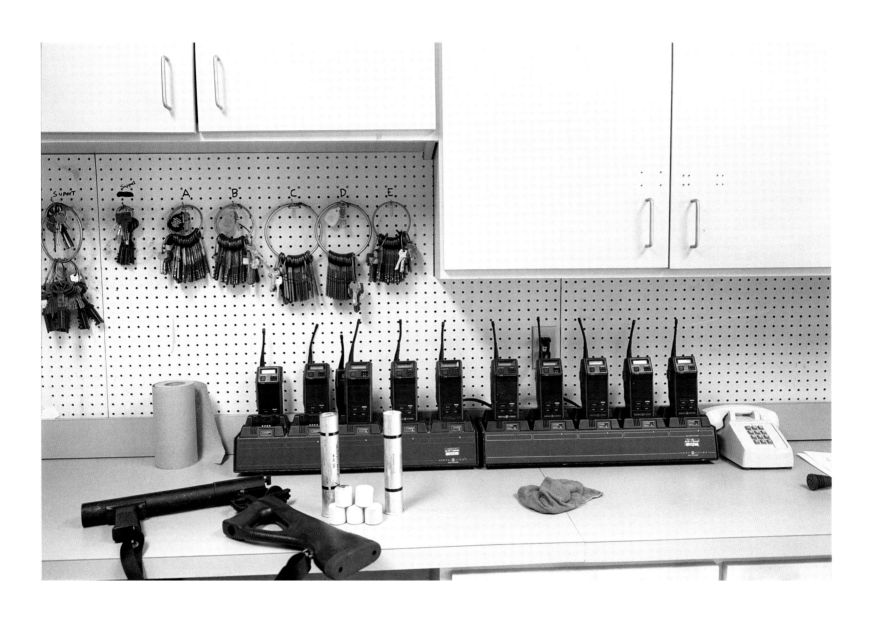

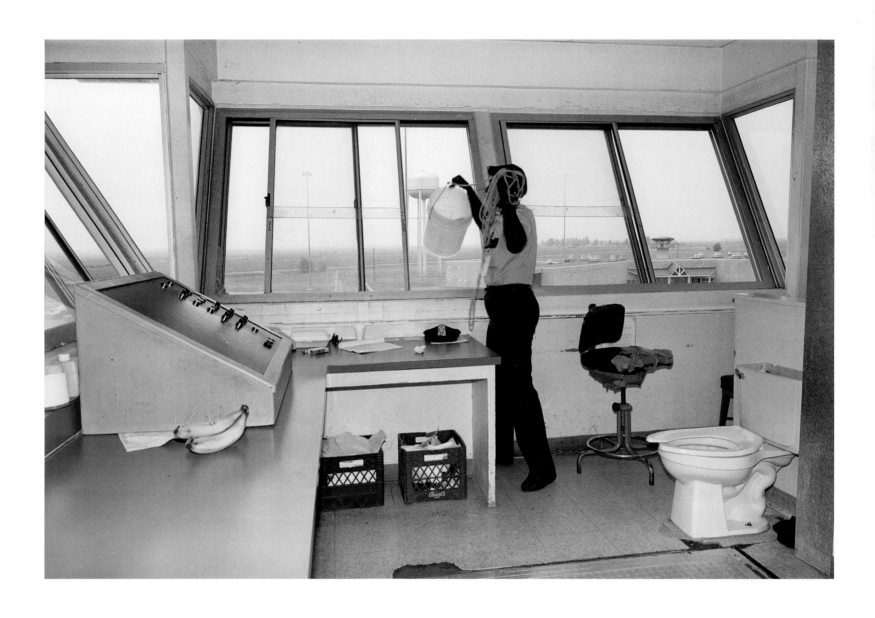

But now I was around Some Real
Fruit loops, They gave me a Cell, and
I went in the zone metting new faces
and alot of the Inmates was white. So
that made me feel more at home, Than
any other Camp So far. I went to
my Cell and Unpacked and shut my
door and went to Sleep, After a few
hours of Sleep, I got up and washed all my
walls and Floor, My bed was made of
Steal, and my mat was 1 inch thick
It's Just like Sleeping on the Floor.
I had my own Mirror and toilet. I
also had a butten to push, to open my
door when ever I wanted to Come out.
I was there only a few hours, and
this white Convict asked me for a smoke
I gave it and he was gone for (1 min)
he came and asked for a Shot of Coffee
I gave it, He was gone again. Then
the next thing I Seen, He had cut
his Neck with a Razor Blood was
every Where, The Officers took him out
and I Never Seen the white Convict

again. I got settled and every thing packed
in my Jocker. Then I went out of my
Room and walked around the Cat Walk
speaking to a few Guys exchanging names
and Where was I from. We had two
showers one on the top floor and one
on the bottom floor. I had started
College at Camp 30 in (Aug) So I was
Stell in College in at Camp 29 I had
to catch a Parchman bus at 29 to take
all the Inmates that was in College.
I was taking Art Class under
Mrs Rushing — 5 I also took Spanish
and American Goverment. Going to College
twice a week help me from thinking of
the time I'm having to serve here at
Parchman. The State Stoped the Grants
for College after December of 94. So
There Were No College in 95, So Staying
at the Camp Not being able to go to school.
Was a big Change, Then they moved
all the Weights out of the Gym, So
They could Put the Kid Program in
the Gym, Parchman was Full. Parchman

Could not take in any More Inmates
Unless they Starting Moving the Inmates
South to (Green co) OR (Ranking co) Thats
What they Started doing. And they Started
Letting Some Inmates go home on House Arrest.
My Mother and Step Daddy had been
Coming to See me every Visit From
Day one. It's hard to See your Family
leave when you Can't go with them. I've
only Seen my 2 girls 3 times in
the Past 2½ yrs That's what hurts the
most not being with my Kids, I have
Pictures I Can look at, But Steel
it's not the Same. I really miss them
More than anything in the world.
I Came up For Parole in April 95
they Set me off For a year. I Knew
before I even Met the parole board
What they were going to do.
A Few more months Past by, I
Met Friends and lost Friends you
get Moved alot here at Parchman
all it takes is a Letter, Say that
This So in So guy is going to
try to excape. And they Move you.

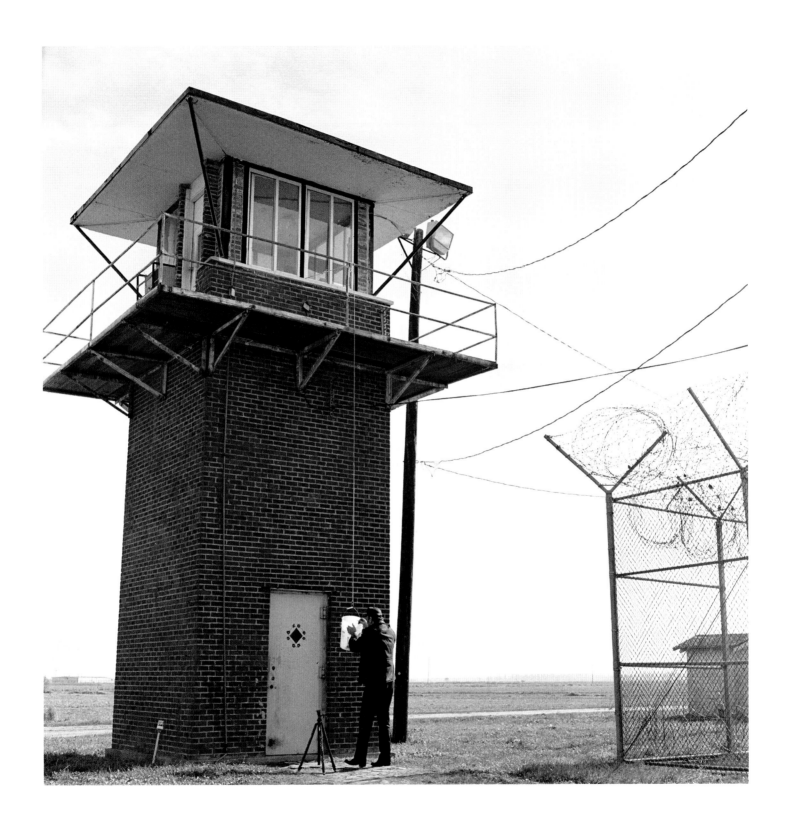

to max lock down camp (32) I'm still
at Camp 29 trying to get my A-custody
so I could go to a trusty camp. I
went infront of classification they set
me off for 6 months. It's Just the
Same old thing every day watch TV or
stay in your room and Read, play cards
Drink coffee and smoke. Every Day
is the same, Nothing ever changes.
Only Time and Hours. And Dates and
then years pass by. December the 25th
on Christmas our familys could bring
you food and be able to bring whats
left after you and the family ate inside
to eat later. It's hard for a person
to live in a place like this. It's
like a hole diffrent world in here.
It's hard thinking of your Kids, and
what they do everyday. And you
always be waiting on mail call.
Mail means alot to a Inmate or a
Convict It really dose. Months started
passing by long months It takes
forever for a month to pass by..

June the (6th 95) I came to Camp 32-D because my time was getting short and I wanted to go home alive, And I didn't wont to catch any more time by getting in a fight and the system takes some or all of my good time. Which I had 3 yrs of good time. I didn't need to give back. Right after I came to this Camp around (July or Aug) Then at 29 they had a big banging Nation against Nation Vice lords and ganstures Fighting each other. I was told that 29 had all the Police and State Police There at 29 staying there Day and night with gun's big Gun's. I'm glad I wasn't there.

But now I'm in this 10×10 Room 24 hours a day and Seven(7) Days a week. This is where time starts doing you. Just set back and think of your self setting in a room the size of a small bath room Day and Night Month after month That's doing time.

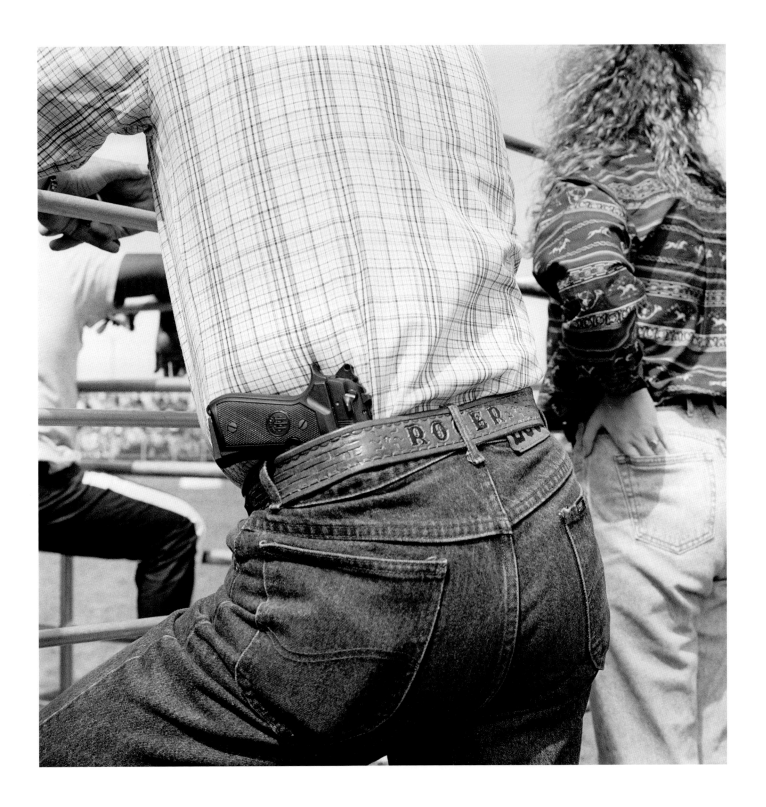

40 Roger with 9MM.

Aug 95 Page 13

In (Aug) they Started putting 2
Inmates in each Cell. So now I
have a Room mate. It's better than
being in the room by your Self. His
Name was Tracy. We Shared life storys
Each day. We made Wine From the
Fruit From our Trays good Wine
too. At the end of September, my
Room mate got moved to another
Camp. That's why a person in prison
can't have a Friend, you always Lose
them in time.

 So now I'm alone again,
the end of October Came, I heard
a Police coming up. "Bam" there was
Psycho a Friend From 29-A building
they Put him in my Cell. Me and
Psycho Stayed in the Cell From
October on though Christmas. I had
to Visit my Family through a glass
Window With Shackles on my Feet
and around my Wast to where my
hands was Shackled to. then we
had to talk though a Phone.

January 1st 96 Page 14

Psycho and I got moved to
Tier 5 on A Zone. This is one
of the Worse Tier I have ever
been on. Inmates was Flooding
every other Night, Just to Send water
to the Canteen, Then they Started
Setting Fire's every night this has
Carryed On until today Feb 22nd-96
I Went up for parole the 12th of
this month I'm Just Setting back
Wating on the Word yes or No.
 Parchman is the Heart of Hell!
Parchman is the Heart of Death!
Parchman is the Heart of Drugs!
Parchman is the Heart of Nation
against Nation!
 "Good by" Parchman I Leave
in December Flat time
 If I make Parole. maybe in a month
OR So.

 Terry Wilkins
 Feb 22nd 96"

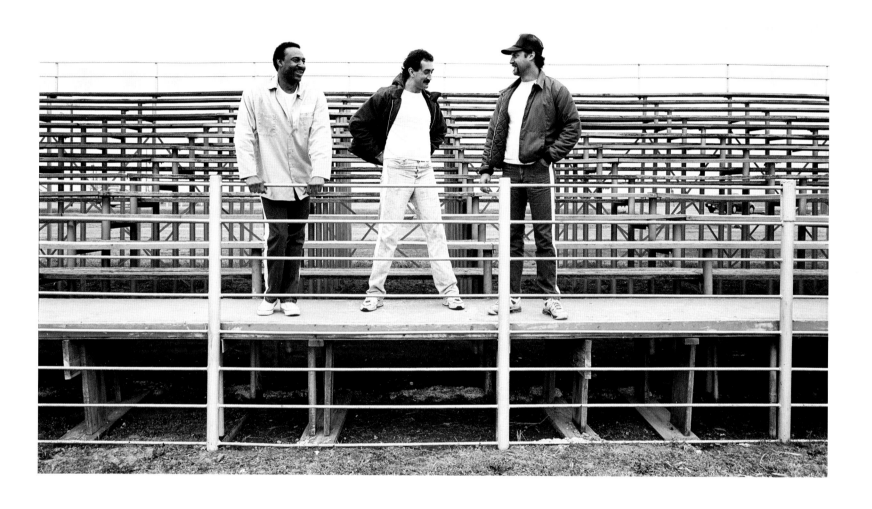

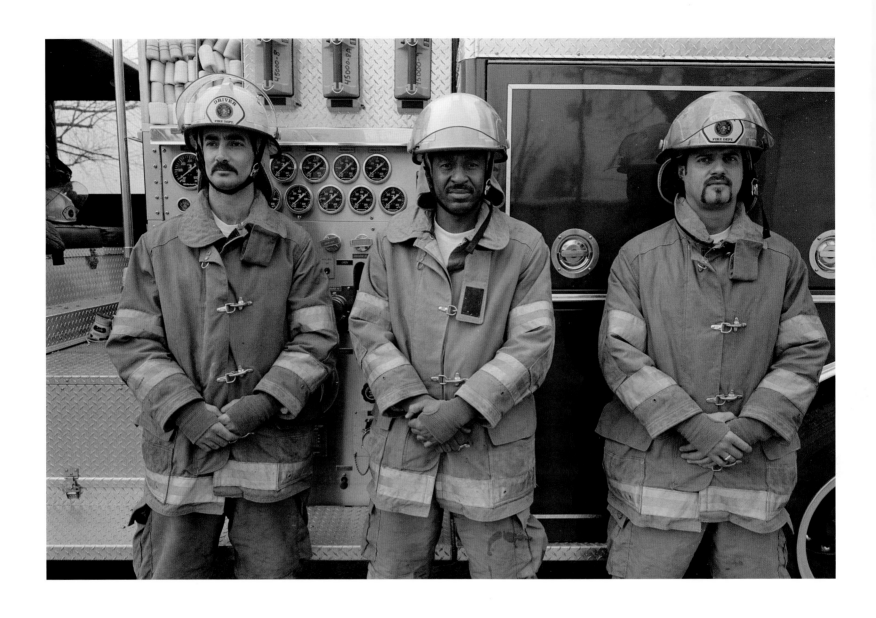

44 Firefighters in turn-out gear.

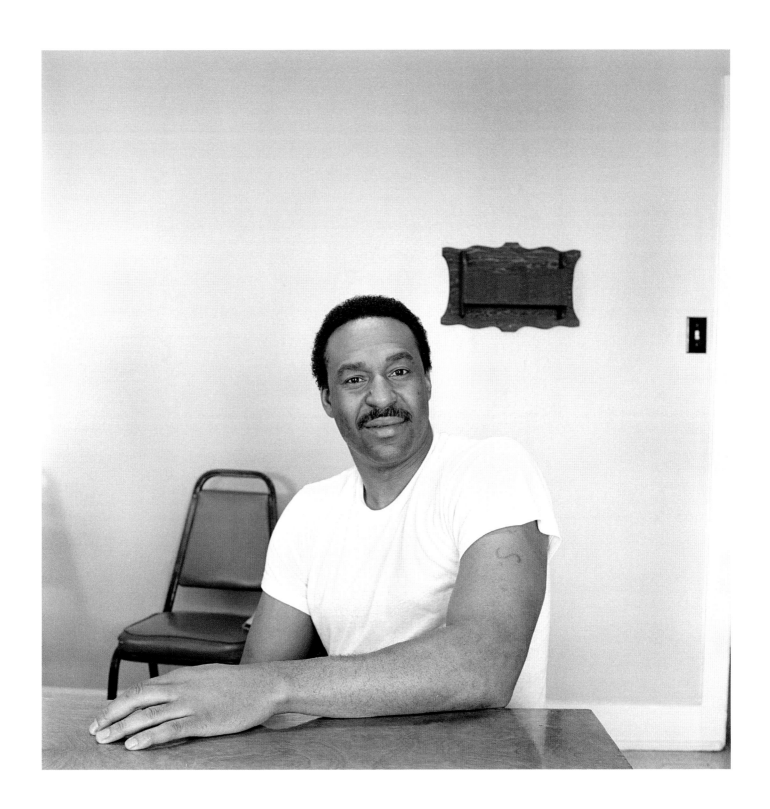

Cornelius Carroll. **45**

My name is Cornelius Carroll MSP 46990A, an ex-project aware member. Project aware was a propram that brought Juvenile offenders into a prison setting to see what life was really about behind bars. Also, I was a member of the project aware traveling team traveled allover mississippi talking to students in schools and colleges about prison life, drugs, gang activities. I have an understanding of gang values and tacties because I am an ex-member of a gang. This information can only be acquired from someone on the inside. For the past (11)years, I have spent long hours working with young people around the state of mississippi. I am serving a twenty (20) year sentence for armed robbery and have served $13\frac{1}{2}$ years of incarceration on my sentence. At the present time, I am assigned to MDOC Firehouse as a Firemen.

A person might ask, "How does one get involved in a preventive program? And what purpose can it serve our younger generation? For me, it began in the year of 1984. The late congressman, Larkin smith,who was sheriff of Harrison Co. And I had deep-rooted desires to fight the war against drugs and gang related activities, by educating the younger generation. Larkin allowed me to share with the public, my past experiences with drugs and gang activities. You see, I was a product of the streets of Jackson Ms, I got involved in a life that included drugs and gangs. As my family, I am blessed today with the gift of life-free of drugs and gangs. I am one out of few who is alive today. Larkin gave me a chance to give something back to the communities, to help young people avoid the pitfalls of a life filled with drugs and gangs.

On Oct. 3, 1990, I was transferred from Harrison County Jail, to the Mississippi State ~~Parchman~~ Penitentiary, here at Parchman, to work with project aware. The people I have talked with and for around the State of Ms are unaware of the gang activities going on around them. It is not their fault, totally, because they lack the necessary knowledge about gang activities. The point I am making is that the teachers, counselors, parents and other that have a responsibility in these childrens welfare, needs to be educated. They need to know how to identify gang activity. My greatest fear is that we might be too late because youth gangs are at work all over the State of Mississippi. We do not have organized gangs in Mississippi. As of yet, but our kids are being approached. The gangs have spreaded in recent years so has the concern for the schools safety, as the problem grows, so does the number of youths who are

involved because they see no way out. The gangs we have in Mississippi today were formed specificly for the purpose of sell crack cocaine. Almost all of the black on black murders occur because gang member were fighting for street corners, and neighborhood for which to sell crack cocaine. Also, I am concerned about the gang problem here at Parchman because once these gang member are released they will bring this problem back into the communities, where our kids play. Young people are coming to Parchman just to learn the meaning, beliefs, symbols and dress codes of these gangs. Gang members learns about these gangs while in Jails, Prisons, Orkland trainning school, Job corps, Schools and their community.

Upon expiration of my sentence, I plan to continue fighting for our youths. In order to put gang activity into perspective, I am going to need full cooperation from the kids, parents, and the community. I must take a stand for our young people. It is going to take an authority figuer, to carry out a task of this sort. When I am released I hope this process will have already been implemented and only lacking my knowledge about such activity if any.

Cornelius Carroll
#46990A Firehouse
Parchman, Ms. 38738

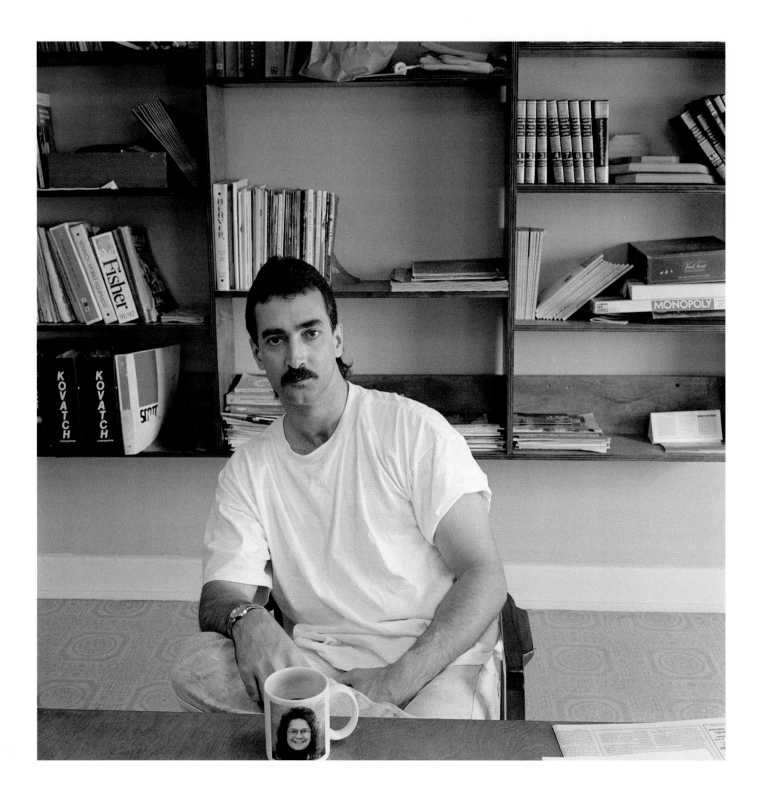

48 Billy Wallace.

Inmate Billy Wallace #05944A
Fire Department
Parchman, MS 38738

I was arrested in July of 1985 on the charge of Capital Murder. In March of 1986, I begin serving a life sentence in the Mississippi Department of Corrections. During this time I have seen many changes take place within the prison system, some good, some bad. The prison system has tried to alleviate much of the gang activity that is present through its classification board, confining the problem to specific units. This is an advantage for men who are trying to do their time and leave prison. At the same time, through laws and pressure from without, the system has seen an increased population growth that has put undue pressures on both inmates and staff.

Coming to Parchman for me was a "life changing" experience. To witness first hand what goes on inside a prison is a whole different ball game than watching "Escape From Alcatraz." I have seen men die in prison, their manhood taken from them, their hopes die, their families destroyed and their souls ripped from them to the point of not even feeling like a human being anymore. In the same breath, someone on the outside who committed no crime experienced the same thing, or worse from someone in prison. The only difference is that many of them have had to live in a prison without bars. Being in prison made me look at myself. My life of "doing my own thing" brought me to this place. It is easy to say, "Hey, I'm doing my thing, it isn't hurting anybody." Every thing we do affects somebody. I have tried to take advantage of this time, to build a foundation for a new life on the outside. My incarceration has given me a first hand look at what lives out of control are capable of doing. My life was out of control until the day I met Jesus Christ. Since that day, I

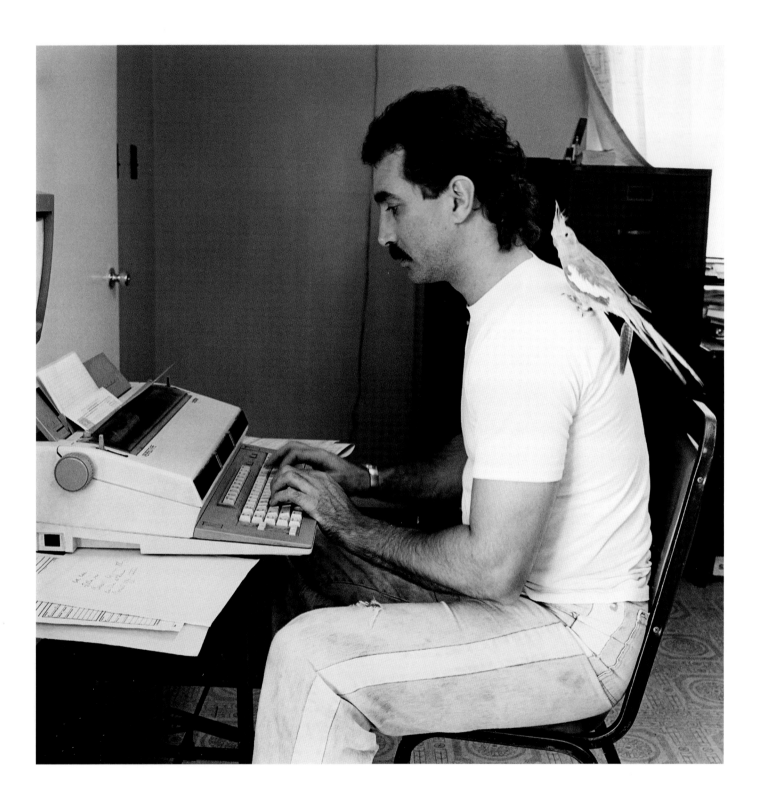

50 Billy Wallace typing.

have sought to live a life within this prison that would be a light to those around me. I truly believe that regeneration is the ONLY way men can leave prison and stay out of prison. There is no program available that will change a person, only God can do that. Men can change their MIND, but only when their spirit is changed, can their mind truly be changed and renewed by the word of God. For many, prison is just a stopping off place, to re-group and "get it together" for the next time around. For many, prison is just somewhere to be, free housing, food and clothing. For some though, prison is a wake up call, a last stop, a final chance. Prison has been my wake up call.

Upon being released from prison, I will going into full time ministry. I have plans to be married soon after I am released and look forward to a full and rewarding life in Jesus, as He has promised. I hope to be able to work with youthful offenders in my area who can be reached, as well as minister to victims of crime. Not ALL men in prison are BAD, many just made BAD mistakes that brought them here.

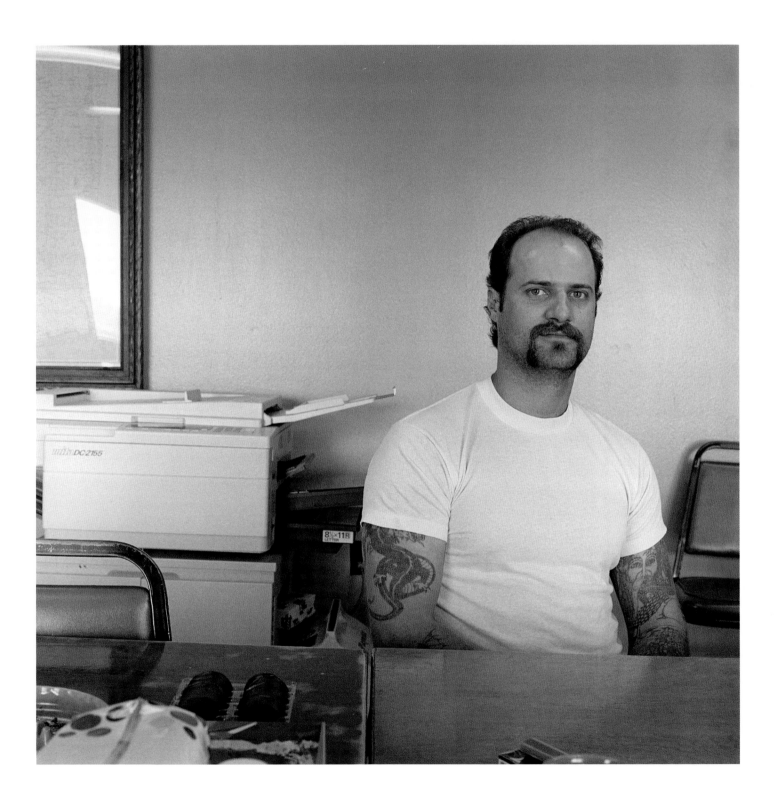

52 Daryl Drennan.

```
Daryl Drennan #33422A
Firehouse
Parchman, MS   38738
```

 Life

I'm serving a life sentence for taking a human life, taking from
someone all that is and could possible be...non restorable. Such is my
only regret for this crime, no regret or remorse for the individuals
personality and morals forever destroyed, as he was a molester of children.
My life is the last he will destroy. I have accepted the responsibility of
this penalty and find comfort in the knowledge that many people out there
did not have their future tainted or destroyed by such sickness that
society knows no cure or treatment for.

For over seventeen years I have lost all opportunities for pleasure or
dreams. Hope is the only rational desire in this condemned society of
confinement. Knowledge is my only gain, the majority of such, I can not
apply.

Life is hope, and I shall continue to wait for my hope to come to
life.

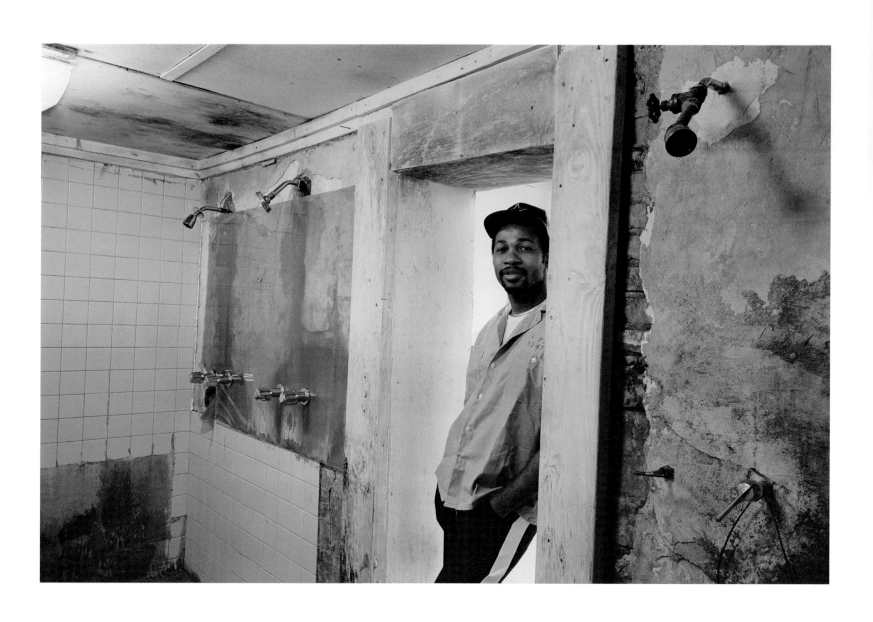

54 Kevin Pack in shower room.

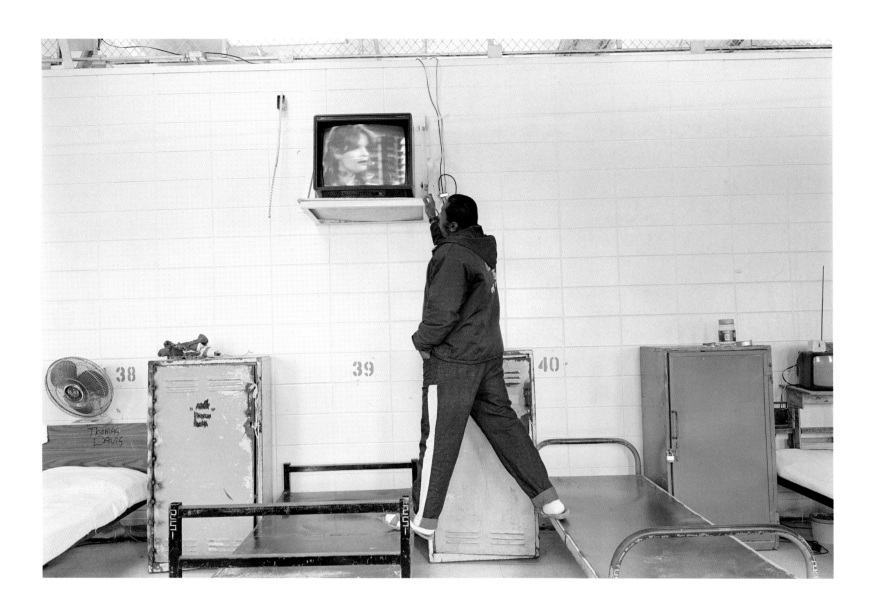

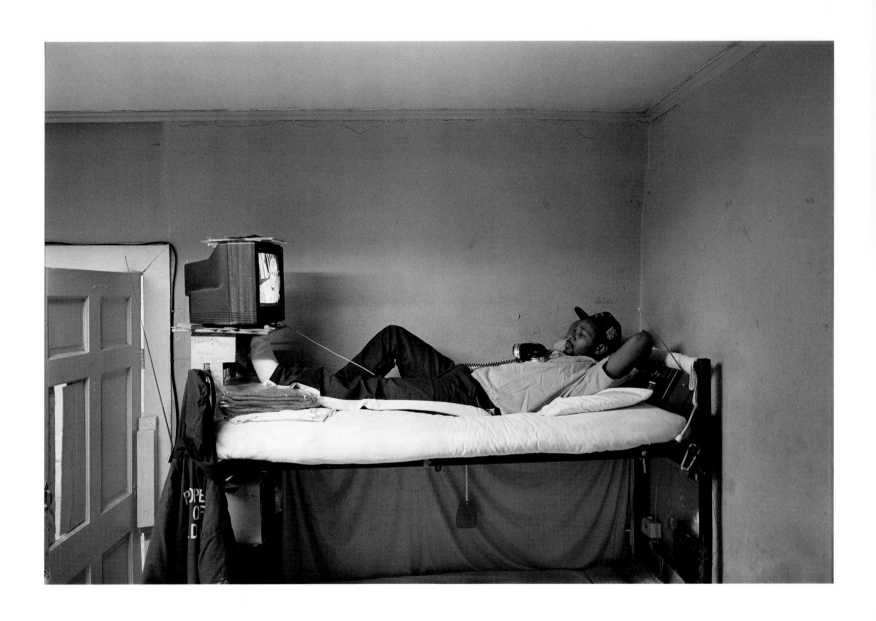

Kevin Pack watching TV.

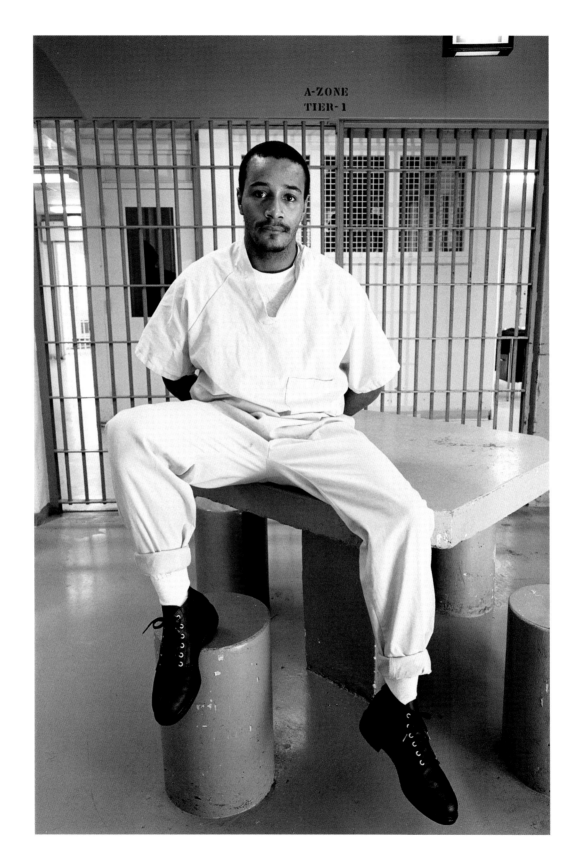

Gregory Applewhite, A-Zone. **57**

Hello, My name is Gregory Applewhite, I'm a 24 yr old black male who is incarcerated at the M.D.O.C. when I first ented the system, I was Kinda scared, nerves, and upset. I felt as if I had nothing else to strive for out of life, I felt like I didn't have a friend in the world, but by me being afraid at that time, Now I realize I was very dangers, you know the old saying a scared man will do most anything, well please allow me to tell you a few of the thing's I do everyday. I study law as much as I can, I play basketball, (I love basketball), I work out, push up's sit ups back arm's ect.

well as far as my friends, & enemies go. I don't consider myself to have friends in a place like this, however I don't go around and try to make enemies, I try to always travel with peace of mind, and peace at heart, so I guess you could say I don't consider myself to have friend's or enemies, I try to keep myself isolated from all the rest, cause my mother always taught me, the less friend's you have the better off you are, and for some reason, or another I'm a firm beleiver in that.

well let's get into the violence here, I don't have to deal with violence much, I guess it's got alot to do with the way I carry myself, I don't talk much, I mind my on business. I mostly stay to myself, out of 60 guy's I might conversate with 2, or 3 guy's. but when a problem doe's come along. and it has before, I alway try to reach some type of understanding, cause I am a firm believer that understanding is the best thing in the world

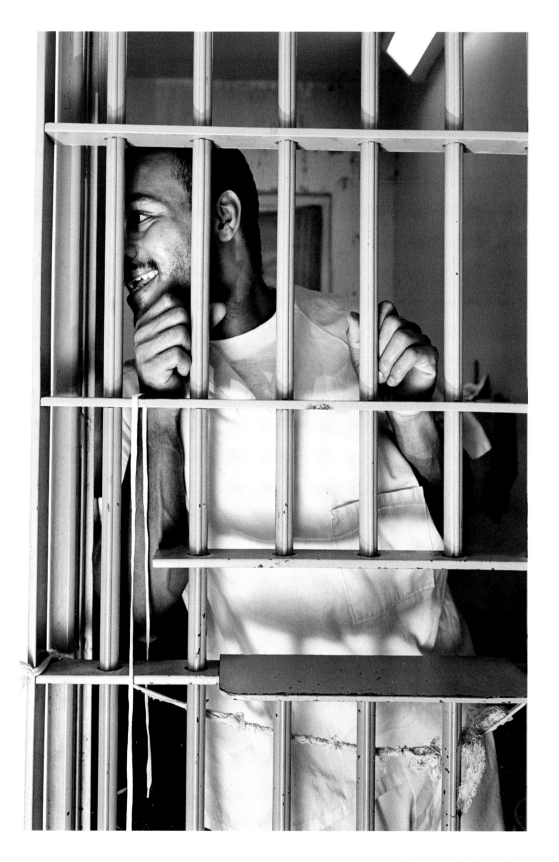

Gregory Applewhite at bars.

but in return I'm not going to lay down and the guy's run over me, I mean true I'm a man that made a mistake, but I'm still a man, but violence it hardly ever come's to me, cause I always carry myself in a respectful manner!

Now we get to the good part, what do I plan to do when I get out of this prison?

I'm going to get married, find me a job, I want a whole house of kid's, leave the street corner's alone, leave the juke joint's alone, and go to church, and try to be the best husband as possible, and raise my kid's the right way, so they don't grow up and make the same mistake I've made in life, or some mistake like this one, or one that can be avoided! I've got one thing to say to the one's who are still out in the world with there freedom, Young brother's & sister's <u>Please</u> don't make the mistake I've made, cause all you'll get from it, you'll hurt your familey, your mom kid's ect. You come here, and you'll become institutionalized, If your not careful, then all you know is the system, then you become programed into is the system, all you know is the system, So please what ever the situation maybe, you can work it out, but you must think, in <u>any</u> given situation!

GOD BLESS
Thank You
Sincerely
Gregory Applewhite

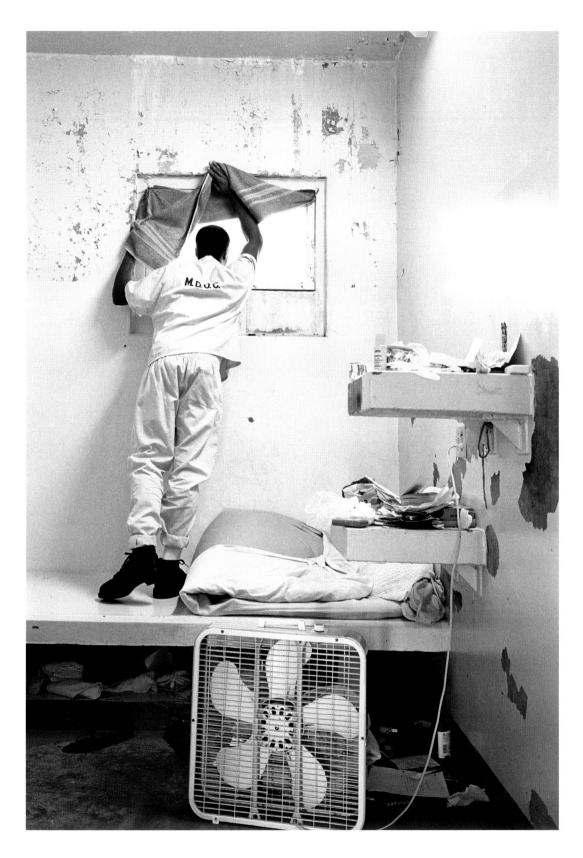

Gregory Applewhite at window.

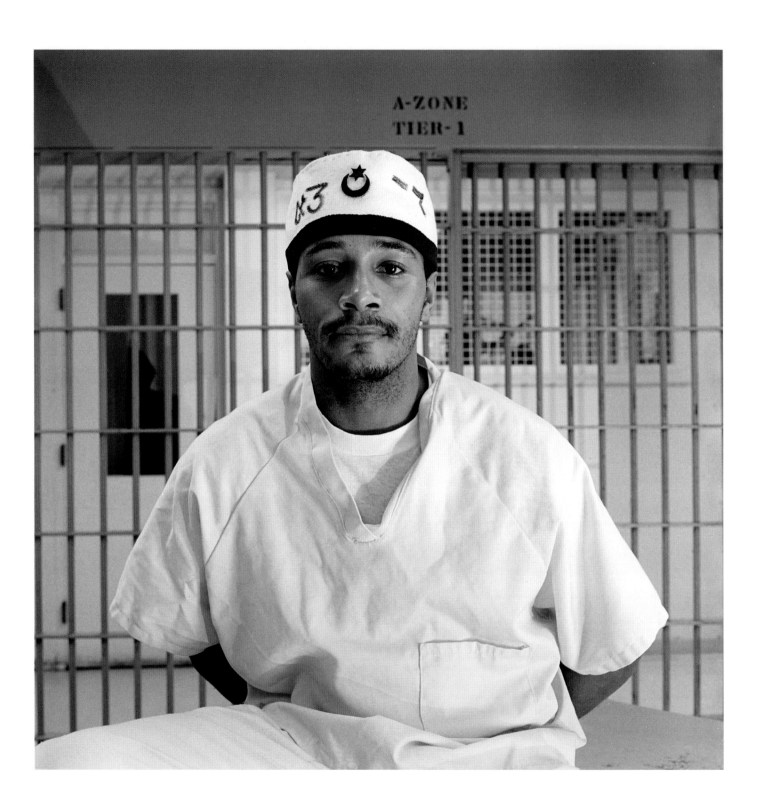

62 Gregory Applewhite with cap.

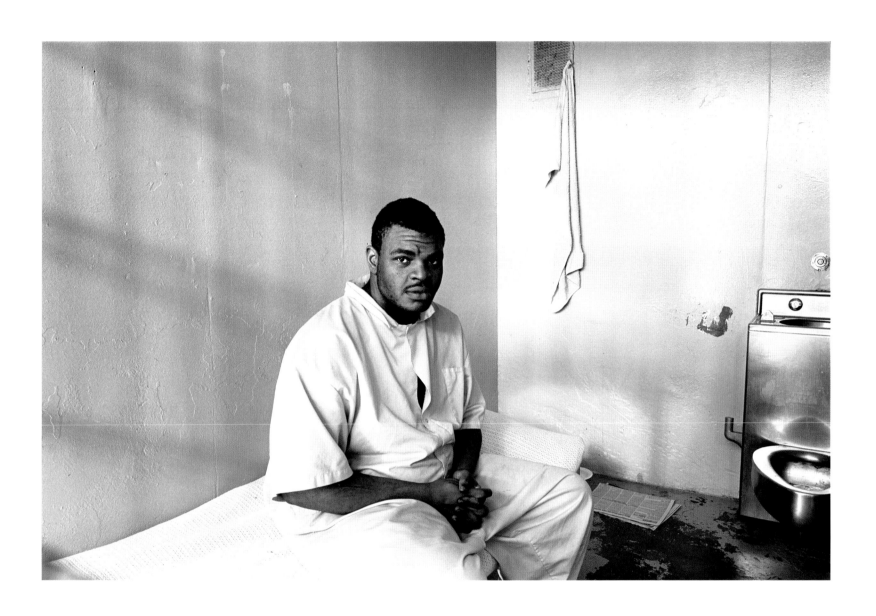

Jimmy Barnes, bar shadows. **63**

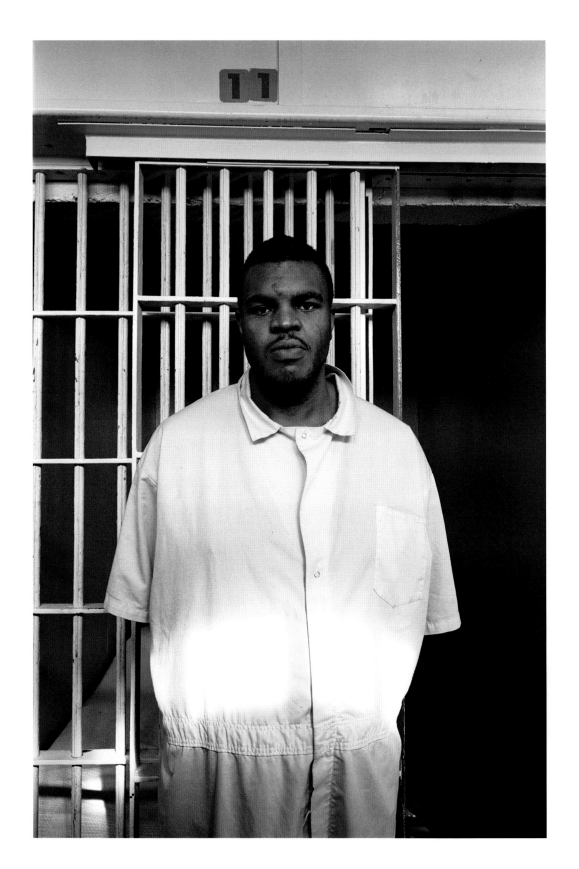

Jimmy Barnes at cell 11.

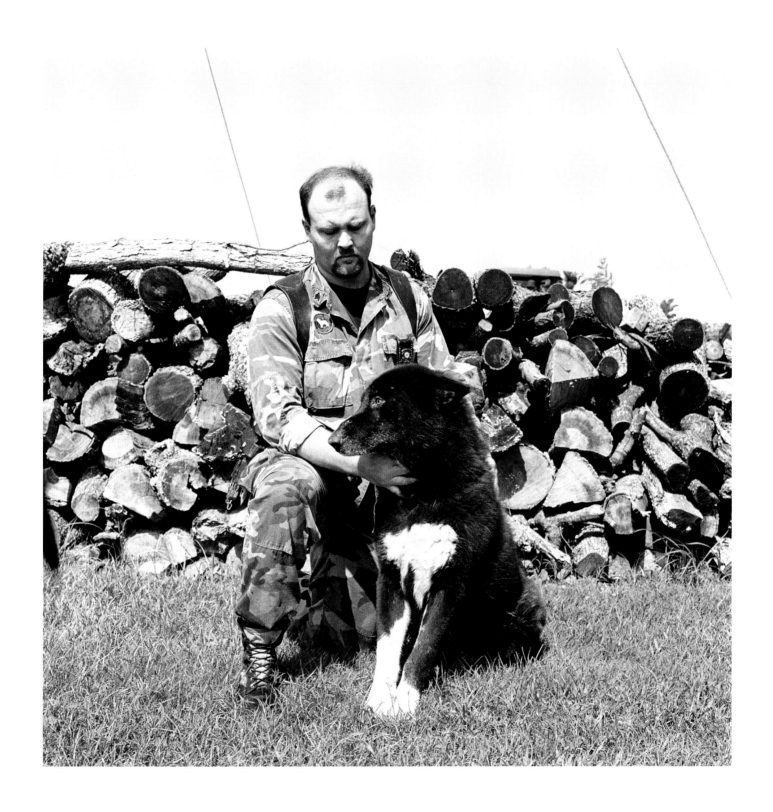

K-9 sergeant with pet wolf. **65**

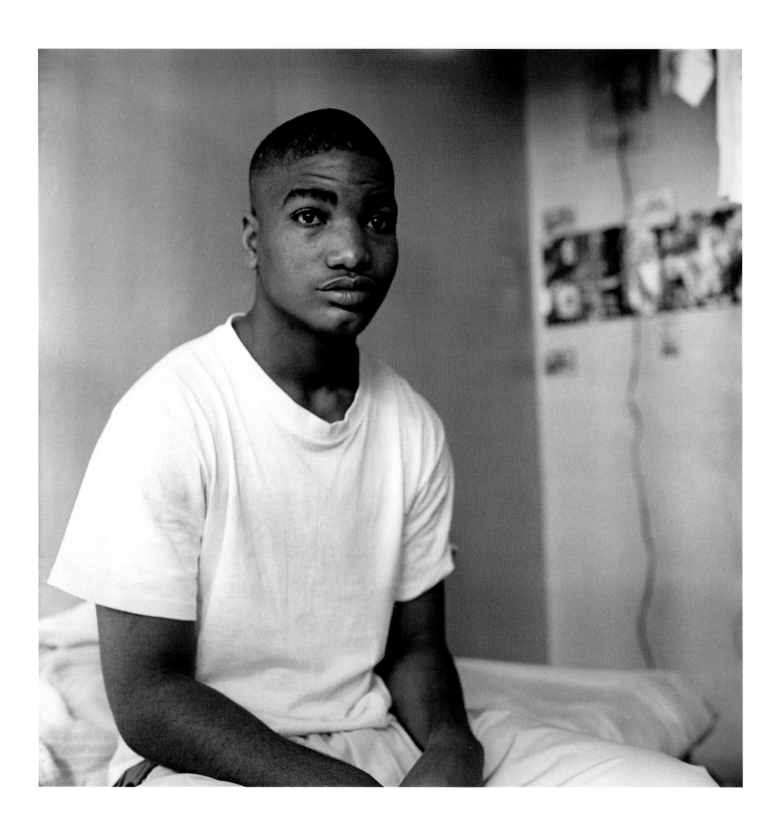

66 Larry Washington, 1994.

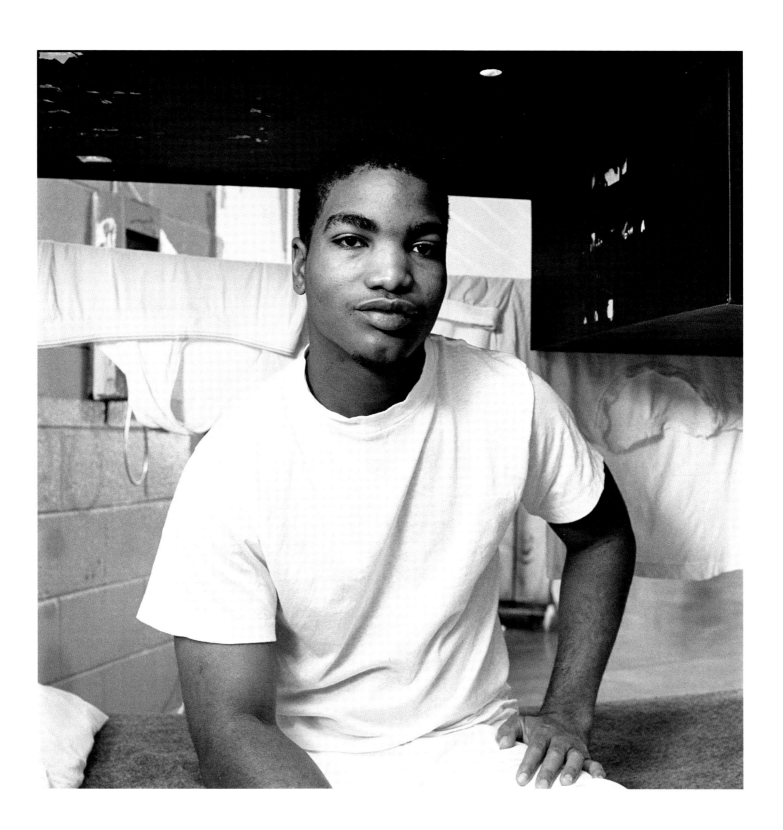

Larry Washington, 1996. **67**

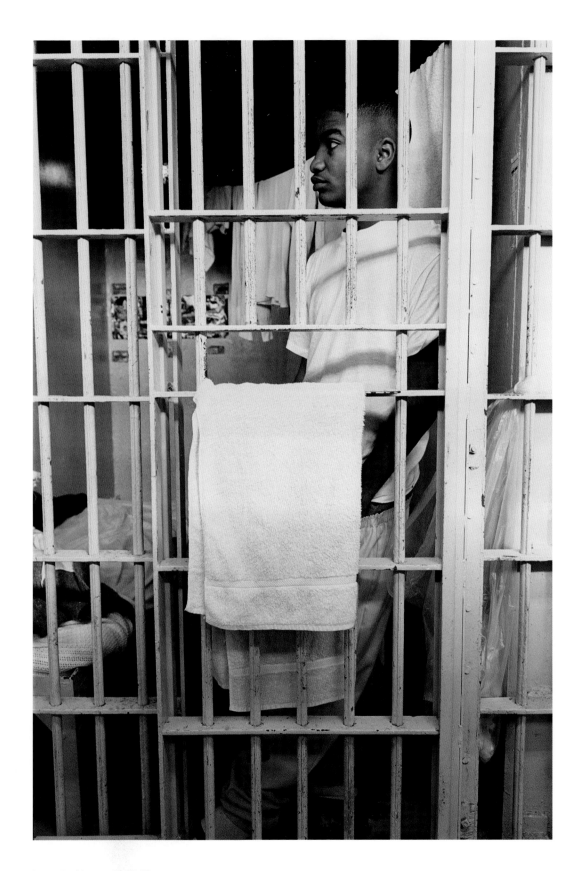

68 Larry Washington behind bars.

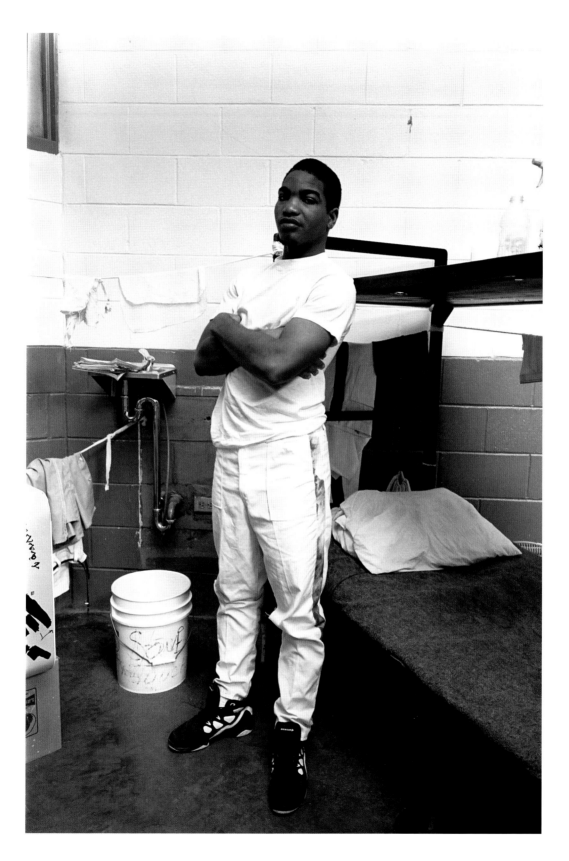

Larry Washington beside bed. **69**

These Are my Everyday Activies

First there's the work aspect. All convicts have to work in order to remain in general population. Convicts are assigned to jobs, were as one would be classified to perform certain dutys here within M.D.O.C.

Field Opperations is the bottom of the barrel, which consist of three units (camps) 29, 23, ~~21~~ and 21/twenty two. These convicts that are assigned to Field opperations performs the task of pulling weeds by hand to planting and picking vegtebles. Then there's those whom are assigned to camp support their dutys are to keep the Housing unit clean and presentable. Which consist of sweeping, mopping, washing walls to cutting grass and picking up any objects that's not suppose to be on the yards, such as cigarettes butts, paper and ect... Then you Have your kitchen workers, yard crews, M.S.E and various Job's of the such that Require Blue pants. So working Here in prison is a MUST To keep From Being lock down

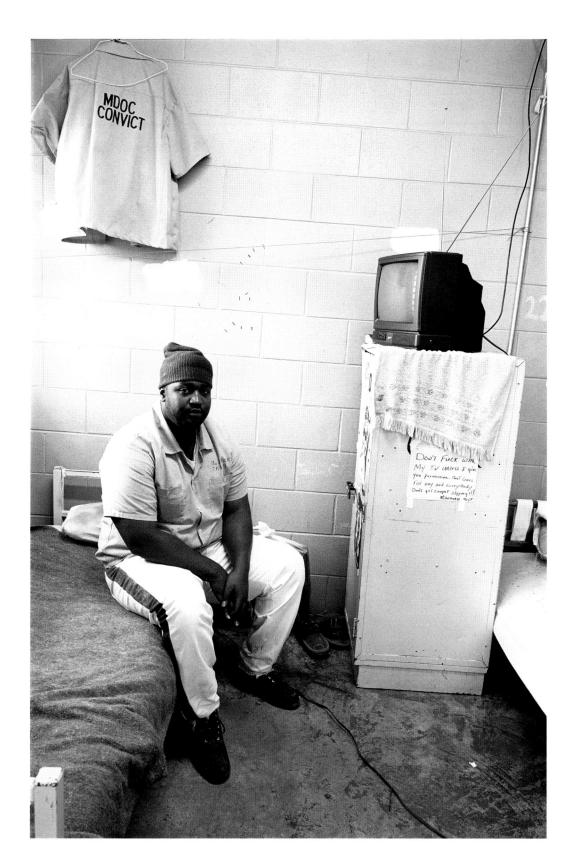

Yes I Have Friends & Enemies

During my stay here in parchman I Have Encountered A many friends As well as Enemies. I would like to say ~~during my stay here~~ so Far I Have Really Been Good friend's with over Half of the population Here in parchman. But By me Being Apart of An Organization called Growth & Developement I Have Encounter Alot of Enemies. But These Enemies Are So call gang Bangers And I'm the Type of indivual who is Easy To get Along with But I can Turn ^{very} ugly when I'm messed with. So To Avoid that kind of Trouble, I Mind my own Business And Do my Time Trying To Think postive.

Now when I speak of A friend I'm Talking about someone who is In so many word's on the Same level As I'm on. ~~They~~ They Think as I Do move as I do And Appericate my Company As much as I appericate Theres. ~~I mean~~ inorder To call a friend a friend in prison you must really put full Trust into some one in so many words your life is in good Hand's with a True friend. That's why All my friends keep inTouch with me as I do them Because In prison A Mans word is all He Have. So your word is more Stronger Then Money or Anything you own or Have. The Reason I Feel a →

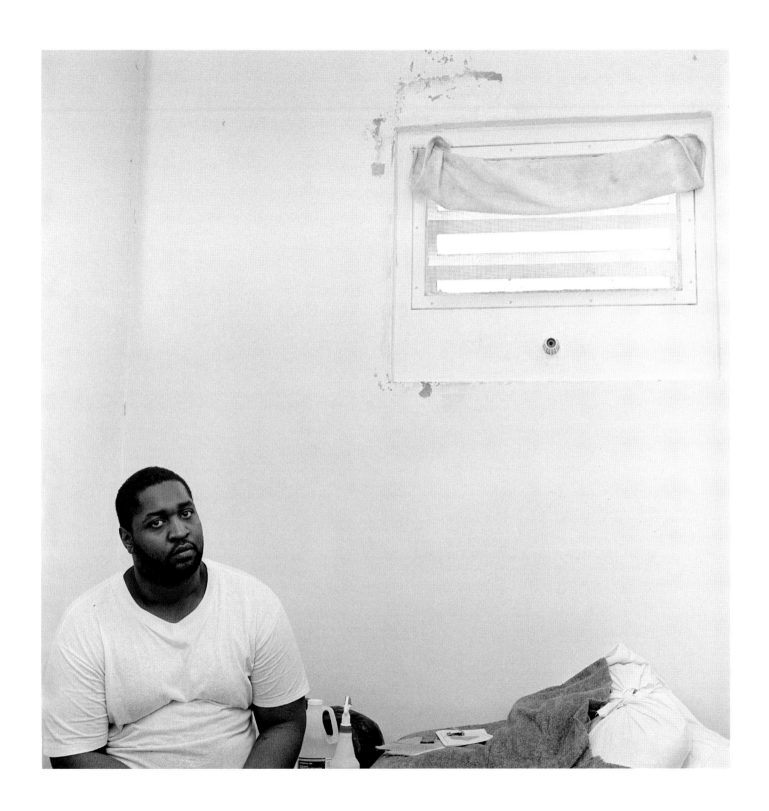

A Friend in prison is more closer To me Then one in Society, That is Because, Here in Prison We live Together 24 hrs a day, And We Encounter A Bond That's Thicker Then a Brick Wall. Where as in Society you might See your close Friend About 3 To 4 days a week, For only a Few Hours. So that's why I Feel in prison you run Across Alot of men you could really call a friend. Because Spirtually, mentally & phyically They There For you. As you would Be For them, And that's what are Friends Are For.

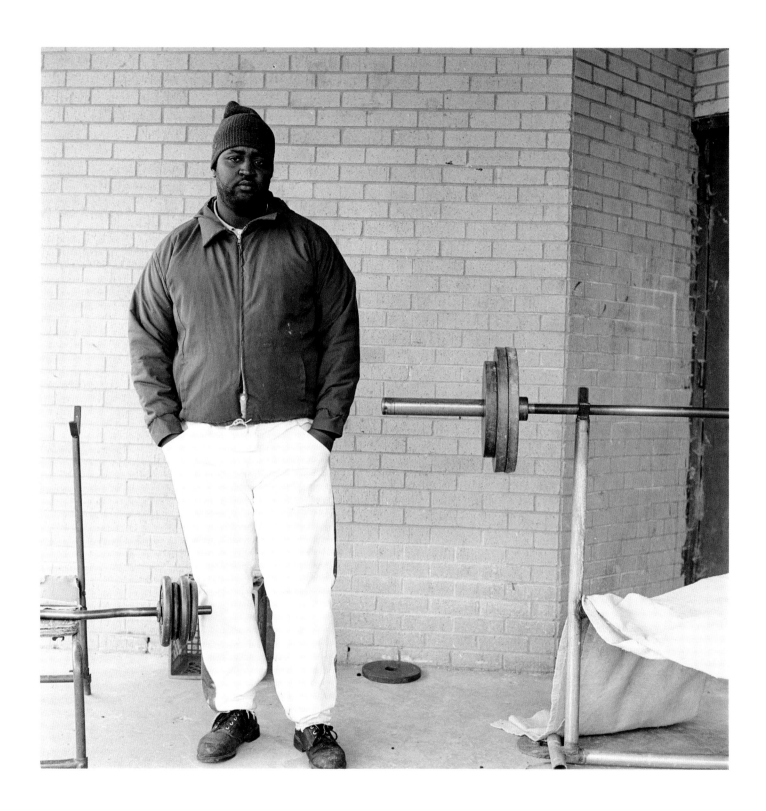

Michael Brown with barbells. **75**

<u>Yes I deal with violence on a regular Basic's</u>

Within The M.D.O.C you will see lots of violence. you Have 2 Different Type's of violence. you Have a verbal violence that you must Deal with on a Daily Basic's Also you Have a phyical violence that you may Encounter with the phyical violence you may Encounter it During a Fight with other convicts and you may Also get into it with the C.O.I Here at The M.D.O.C But I Honestly Feel There is something BeTTer To be Done Then To get Hurt. knowing That your Health is the only Thing you Have Here in The SysTem.

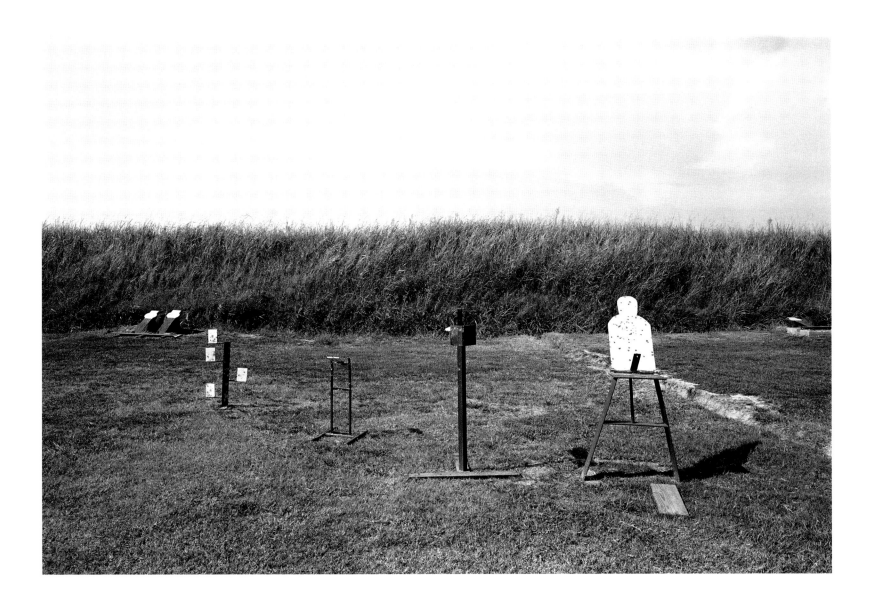

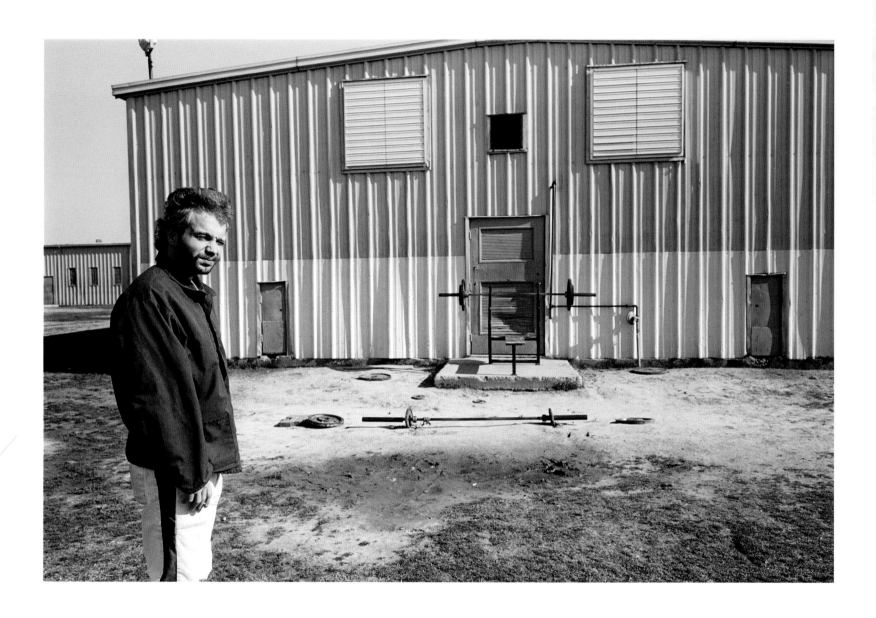

78 Kevin Gentry on the yard.

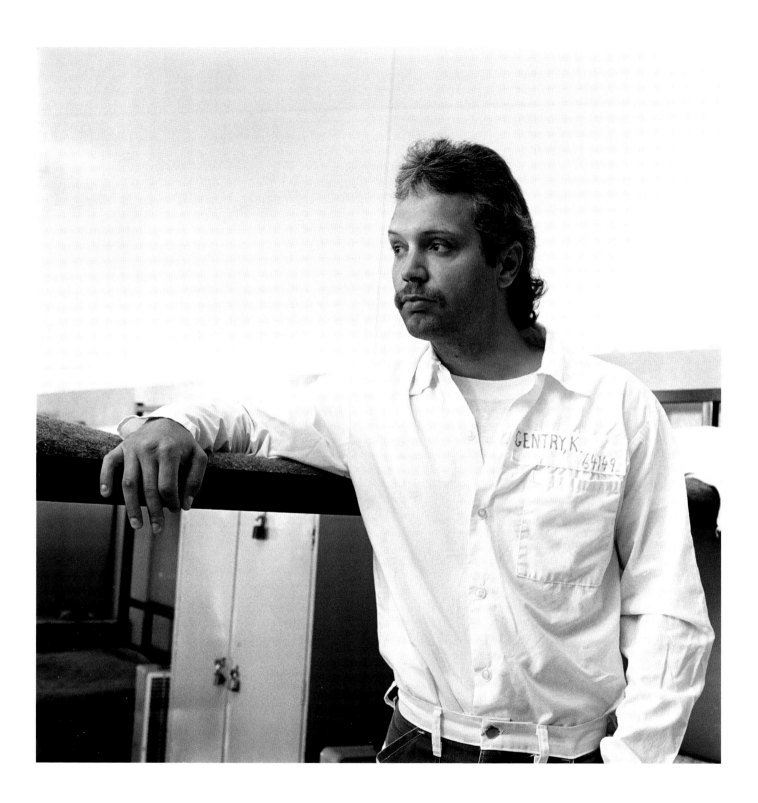

Kevin Gentry, 1996. **79**

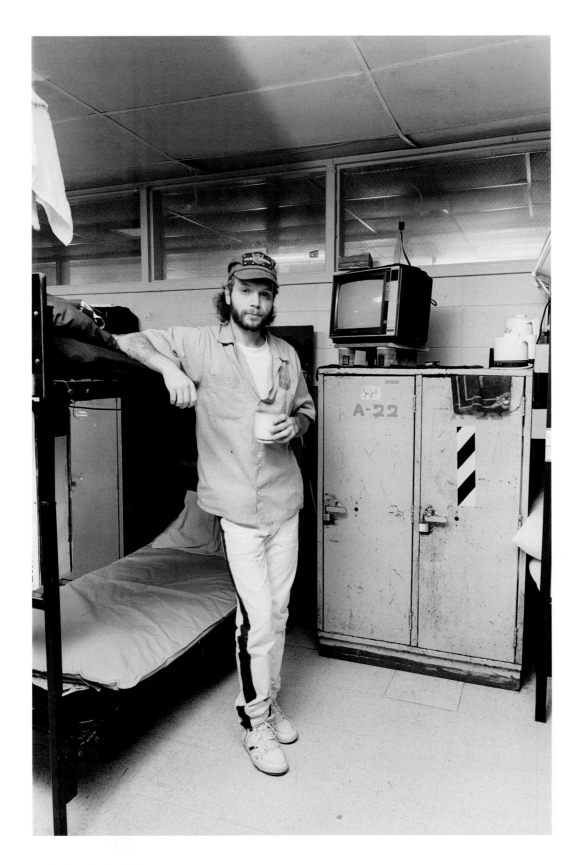

80 Kevin Gentry by bed, 1994.

Spaghetti, central kitchen. **81**

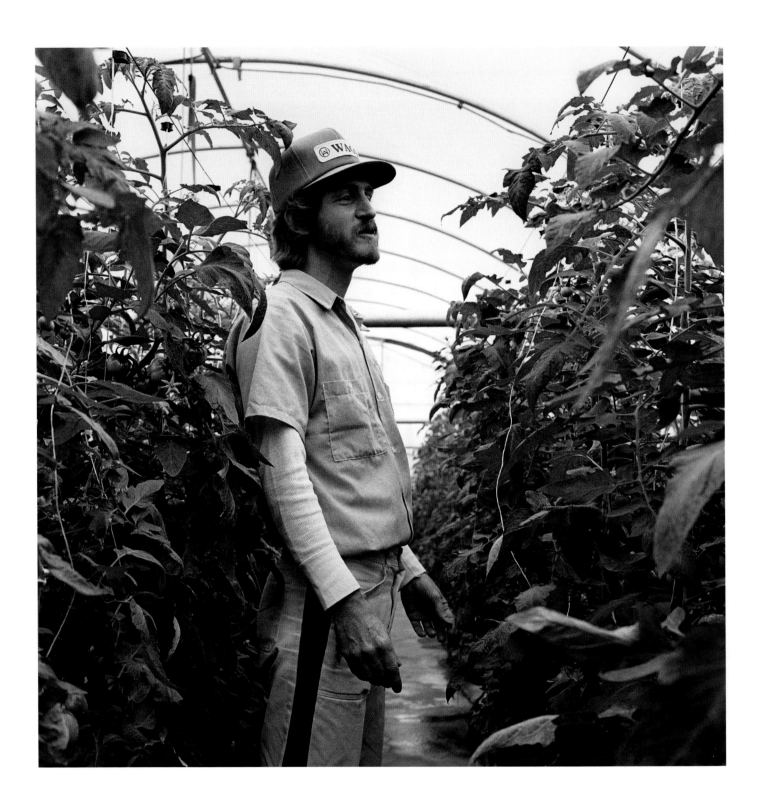

82 Marty Montgomery, 1994.

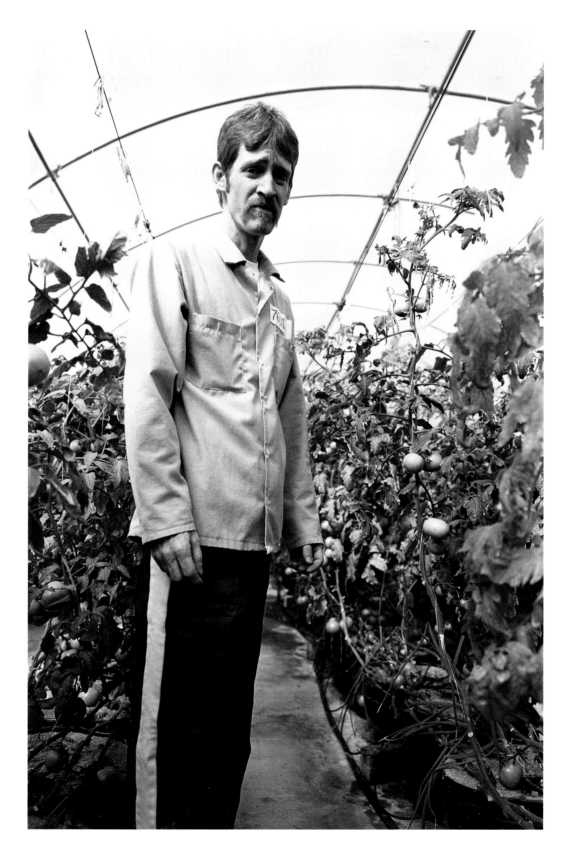

Marty Montgomery, 1996.

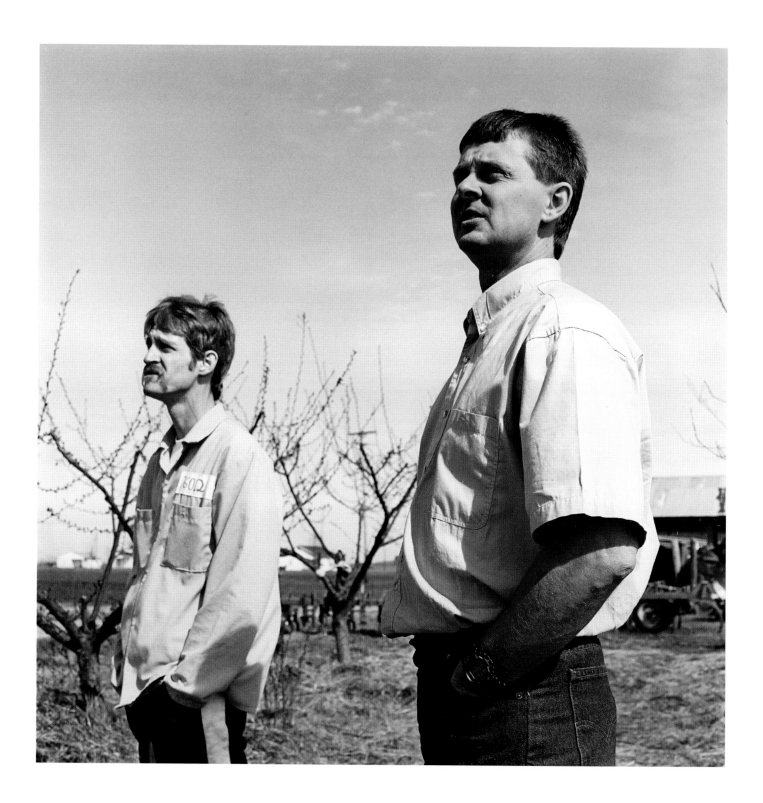

86 Marty Montgomery with civilian boss.

an inmate trying to change his life. It's like they want to promote homosexuality, gang violence, and anti-social or anti-societal forms of living. The harrasment I go through to attend church, school, or any uplifting form of intelligent assertion is harrowing. I'm to look upon the guards as my peers with respect, that's not possible, for the majority of them are lower forms of life than the inmates locked up in here. The guards steal from the inmates, they steal from the state, and most are psychologically misfits.

But still, my success or failure depends on me, not the other inmates and their outlook, and not the guards with their intrusive and degrading attitudes, my becoming a stable citizen rests ~~solely only~~ soley on my shoulders, it's a little late in life and a disgusting place to have to learn these facts, but at least I've come around.

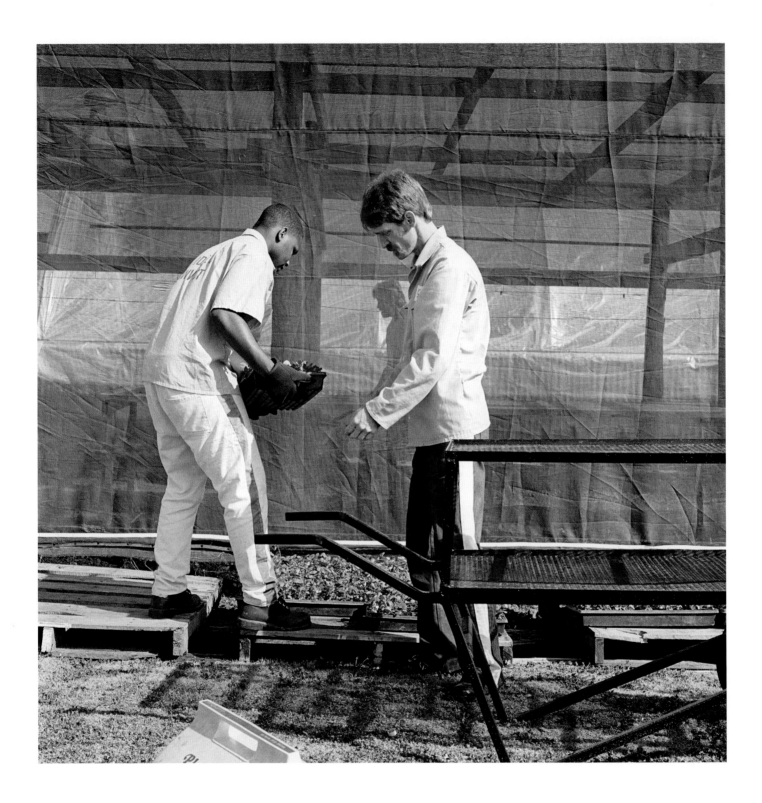

Marty Montgomery working.

Anonymous

Every day I awaken from my hard steel bed I
ask myself, what have I gotten into. I dread for my
mind to refabricate the past events, that caused my
4½ years incarceration. As my mind clears and my
eyes begin to focus, I look upon the numerous cell filled
racks. I notice that the same thought illuminates from
my fellow inmates faces.

There is no sense of me dwelling on these thoughts.
So instead I vigorously raise my cramped body from
the bed, to take aim for the incessant routine that
makes up my day.

Many times in a day nostalgia stirs up
thoughts of what my days use to be like, before my
imprisonment. My favorite thoughts is of my family.
I try to think about the number of things they could
be doing to occupy their time.

I try to envision my wife every day lifting from
our bed alone. But many times those thoughts that once
brought hope, quickly change into profound depression.

It's hard to hold on to old memories but
I try. Just to believe one day soon I will be return-
ing home. That is my only incentive that keeps my
head up and me away from violent confrontations.

That one desire, to return home and live again is
the most powerful urge I have ever came in grips
with.

90 Ivy heart.

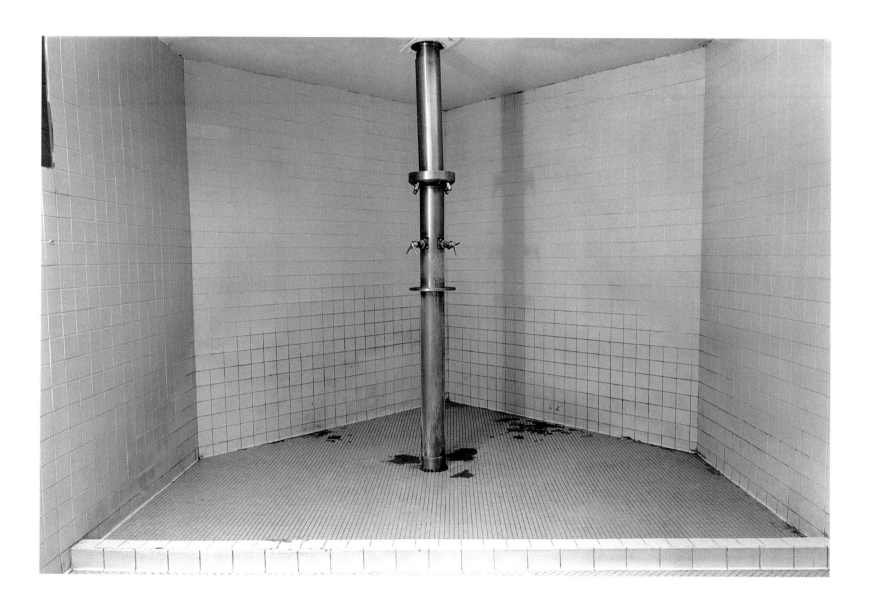

Communal shower.

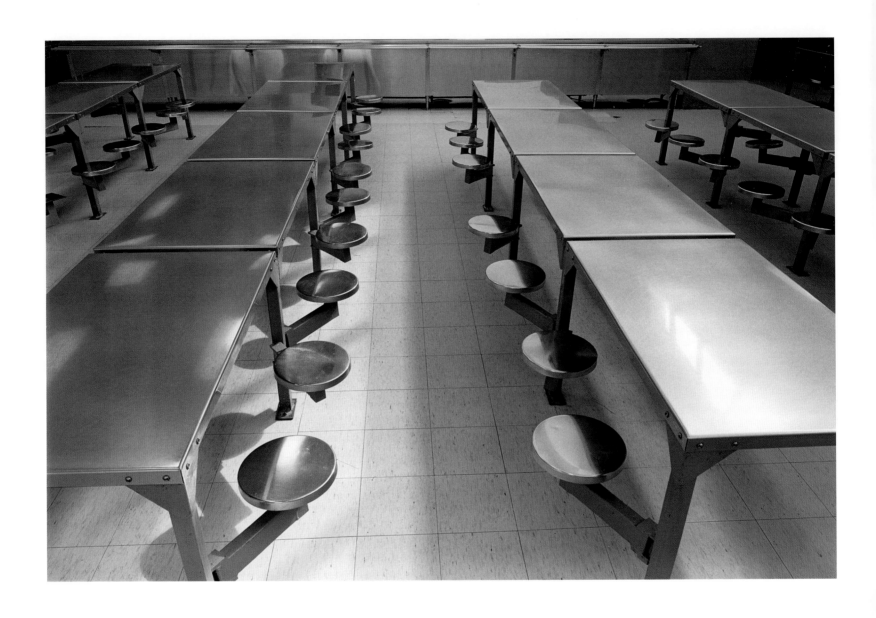

92 Stainless steel dining room.

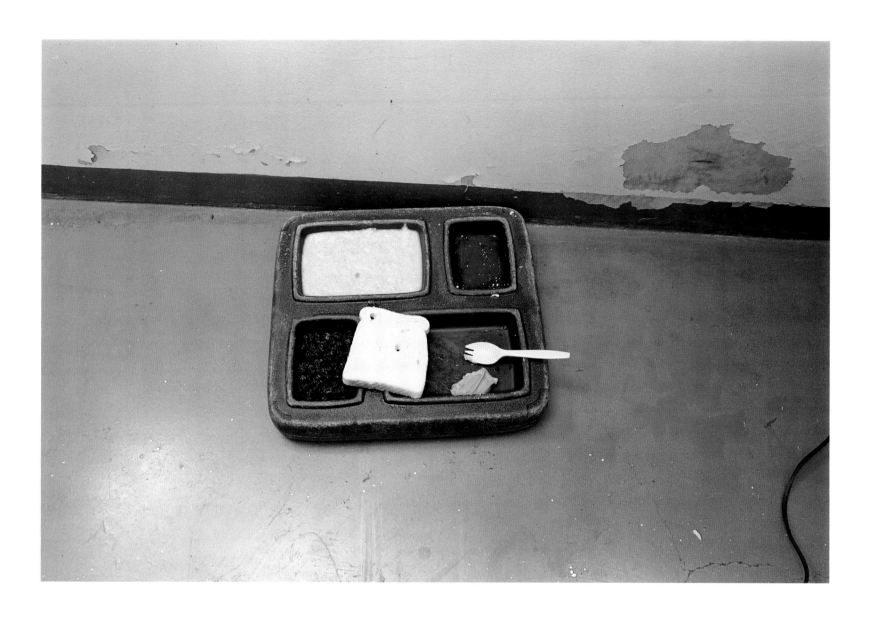

94 Feeding the spider.

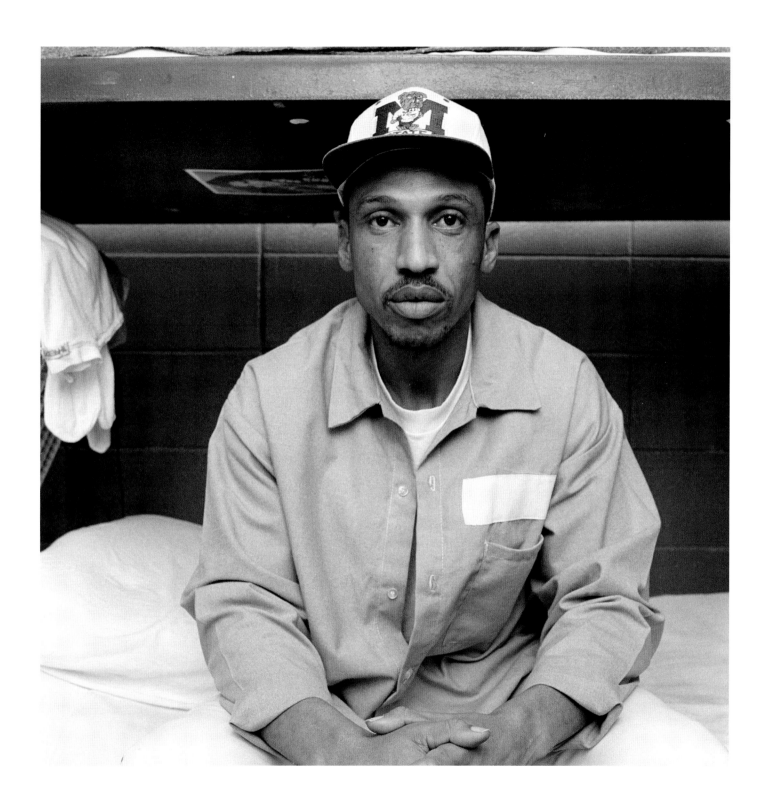

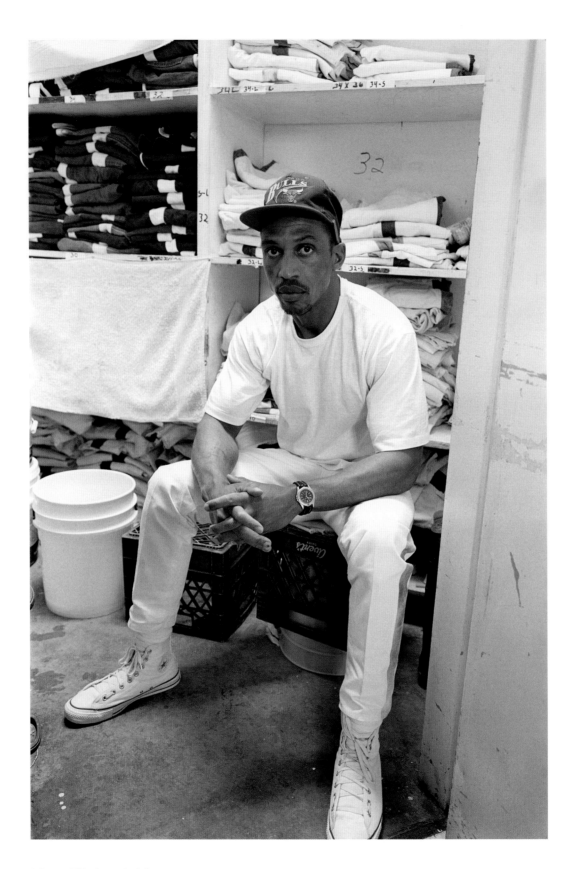

96 Johnney Thigpin on the job, 1994.

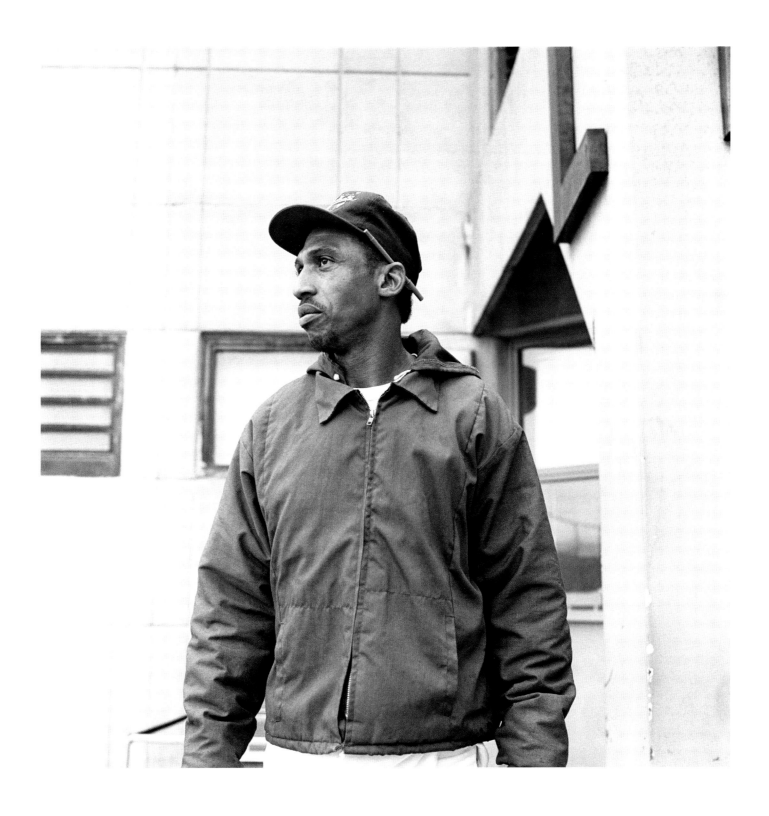

Johnney Thigpin on the yard.

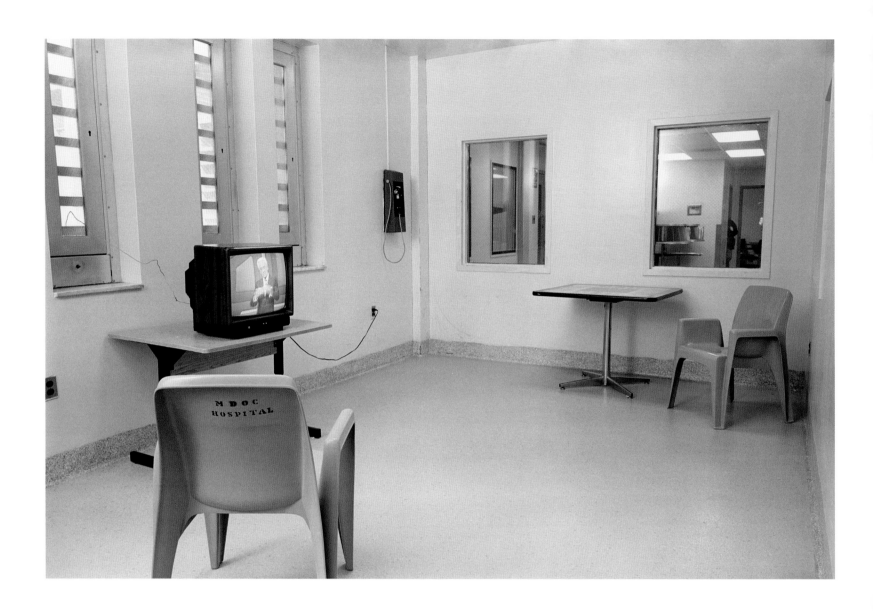

98 Hospital lobby.

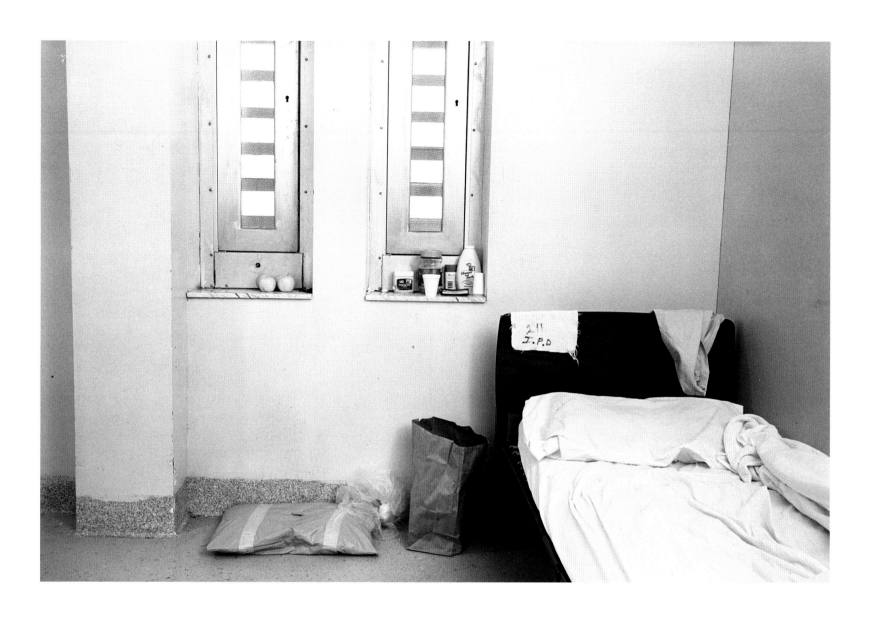

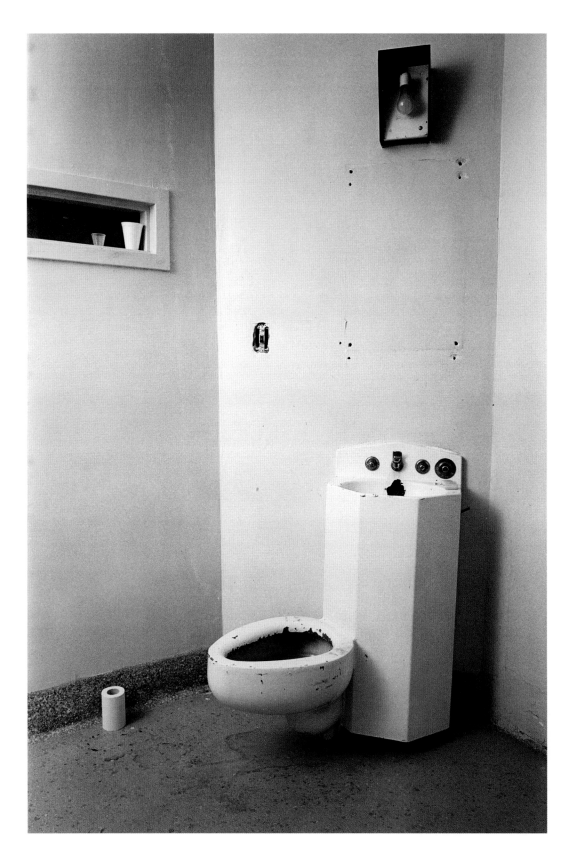

100 Hospital toilet.

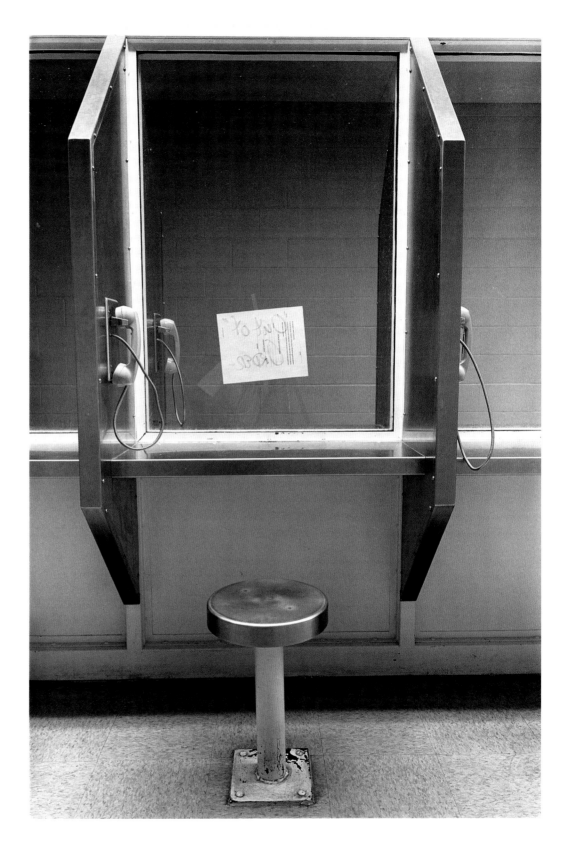

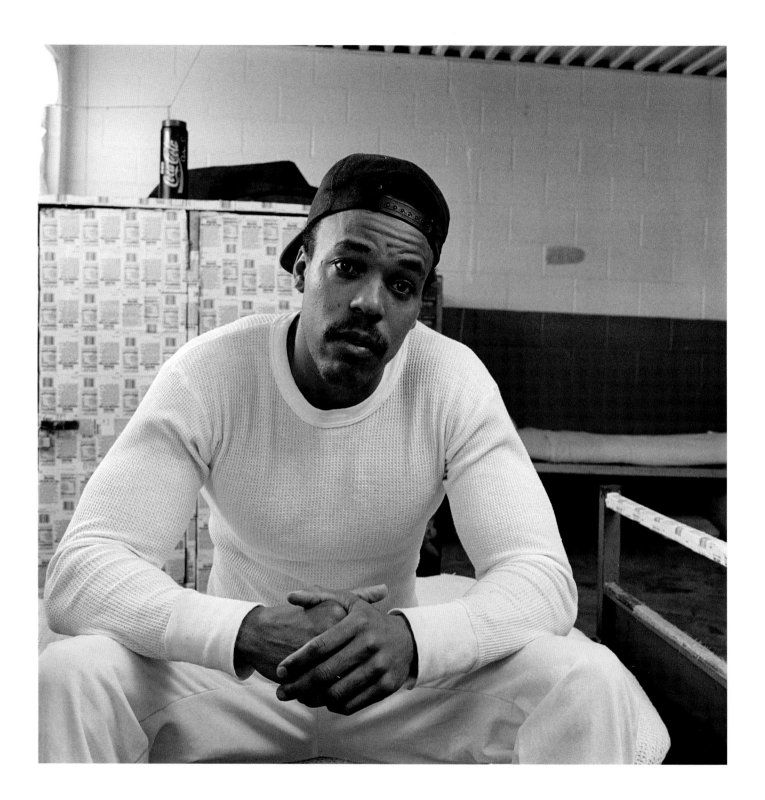

102 Jerome Spotville on bed.

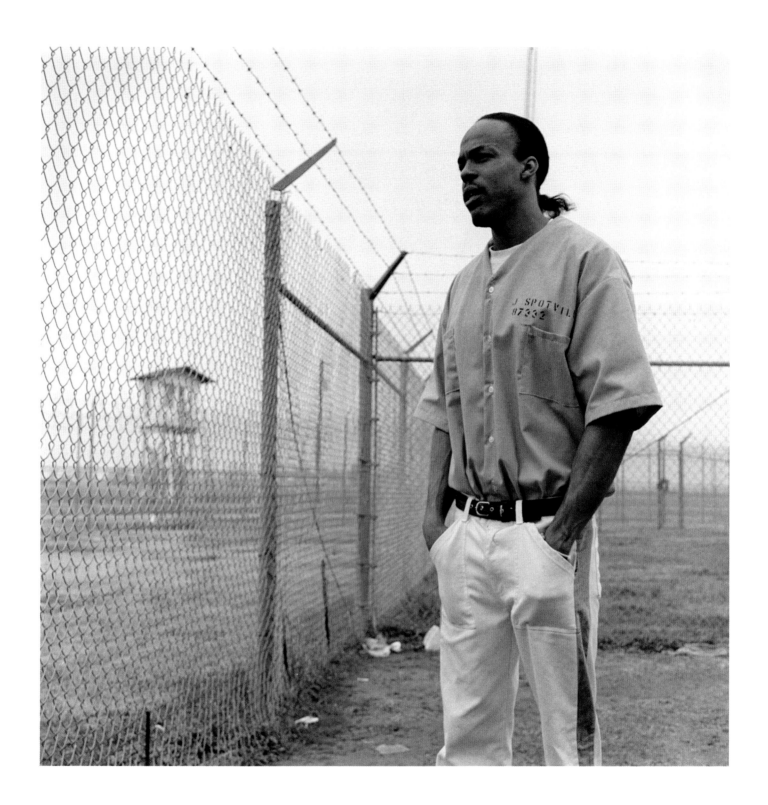

Jerome Spotville at fence.

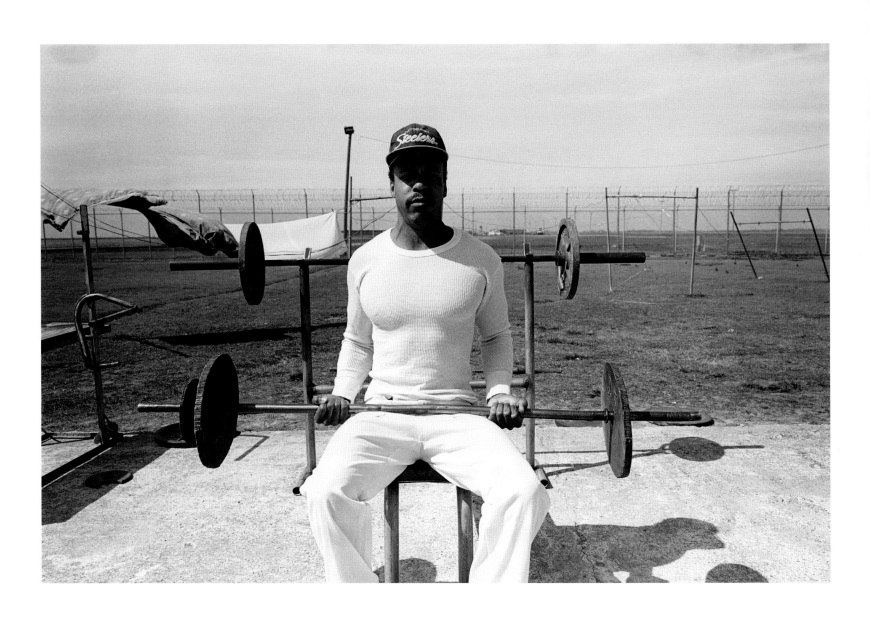

104 Jerome Spotville doing curls.

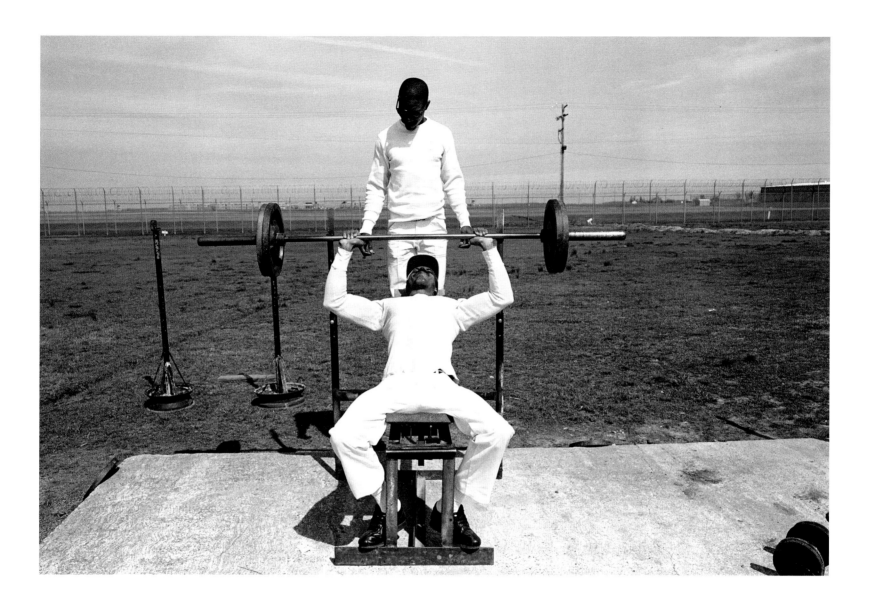

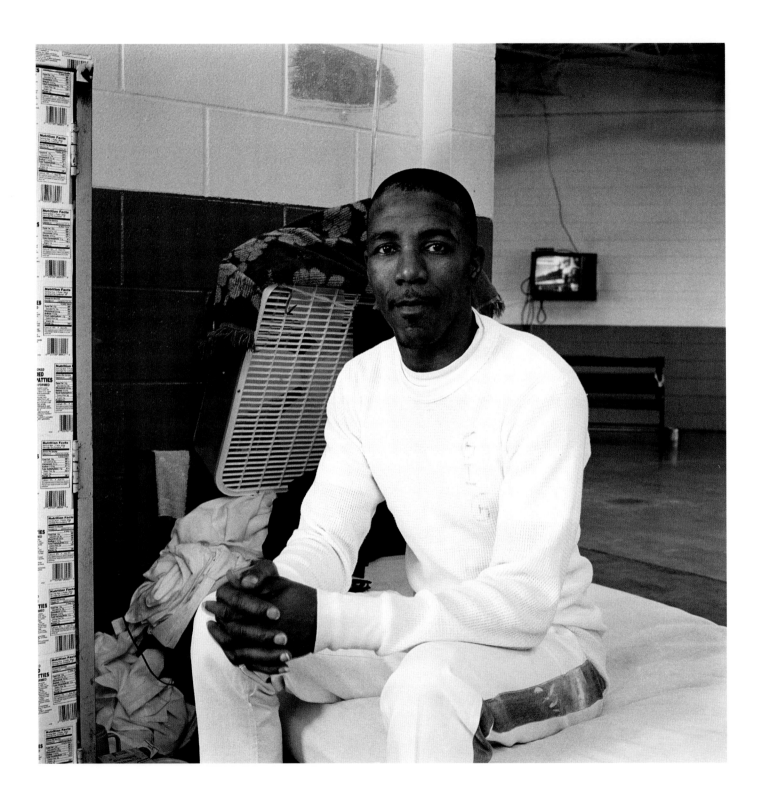

Ronnie Wells.

I came to parchman 3 yrs. ago, and even though this is not my first time here, this is not a place I wish no man to have to come. Being here has taught me a lot, but there is a lot about this place I would never teach to anyone. But would share, with hopes of discourging them to come here. I can say something positive about this place, but if you are doing time, you have to want something positive, in order to get something positive.

Over all there is more negetivity about parchman than anything positive. But it can be what you make of it. When I first came back this and my final time, I was exposed to gang activity, which I had never seen here before. Its clearly visible and one of the reason for the negativity here. And that in itself encourages most to be or get involved. And can easily cause problems for someone who as we say, is trying to make it. I personlly beleive the administration could put a stop to it or atleast control the gang activity a lot better. But thats another part of the negativity here, "The Administration" I pray it gets better, before it get any worser.

Basicly there is nothing to do here day after day. Unless you are fortunate to get in GED classes or trade school. Some get lucky and get a decent job. But most work in the fields.

Its kind of hard to really have a friend here. I personally dont have a friend here. My friends are God and my family.

Friends are hard to come by here, but enemies are easy to have here. What I have to say about that is, deal with it when it comes, the best way you know how.

For entertainment, most guys watch TV practically all day long, until "rack down 10:30pm." Or play cards or dominoes.

From my point of view, those are things they seem to make sure we have, and serve as a deter~~sent~~ from

deterrent

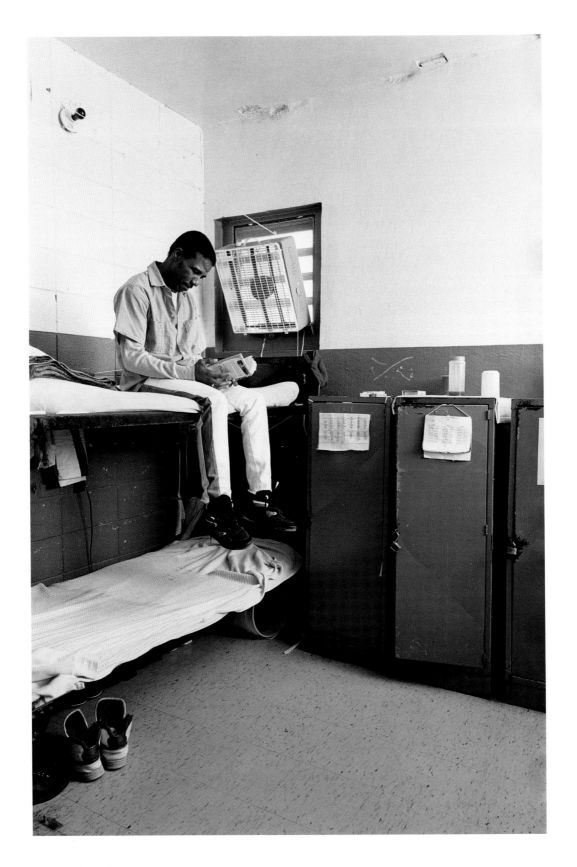

Ronnie Wells reading.

rehabilitating themselves. Guys come in the door heading straight to the TV or card table and spend just about everyday there, and don't even relize they could be doing something more productive. As for violence, It defintley exist. The best thing to do, is try and avoid the trouble makeas. But that cant always be done, and could easily cause probems for one who is trying to make it. And I'm trying to make it, so I can get out of here. And go back to school and get my degree, then start my profession, and start a new life, and never come back to parchman.

By: B.K.A. GIG

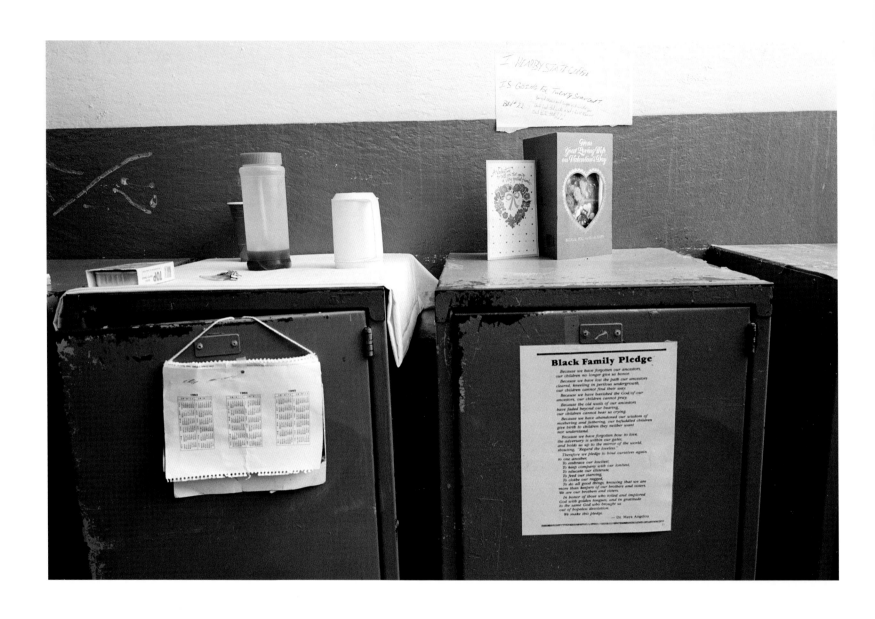

Black family pledge.

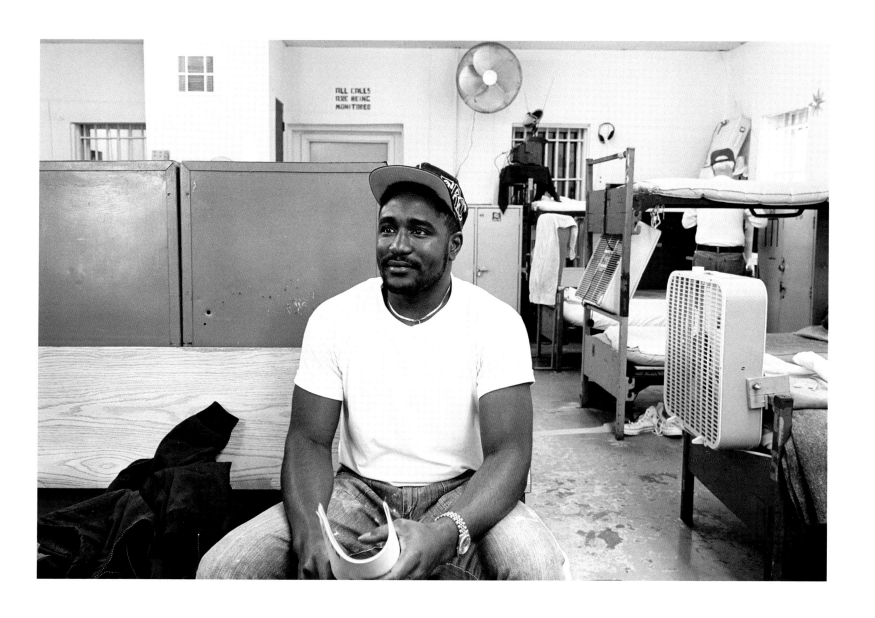

Leake Harris

There are many places in the world to be, for me, it is prison. As a young black man, life is difficult. And I didn't make it any easier by closing the few door that were open to me.

I grew up in a home, where we didn't have much. So it not hard to see, as an aldut, I want all the things life had to offer. I had a job that pay very little, so my bills got larger. I tried to find a job that paid more, but for a person who didn't finish high school there aren't many option.

On a trip to New Oleans, I meet a guy that showed me a way in which I could make alot of money without working myself to dealth. It was transporting drugs. So there was some alteration to my car and I began making trips. Each trip paid five thousand dollars. There

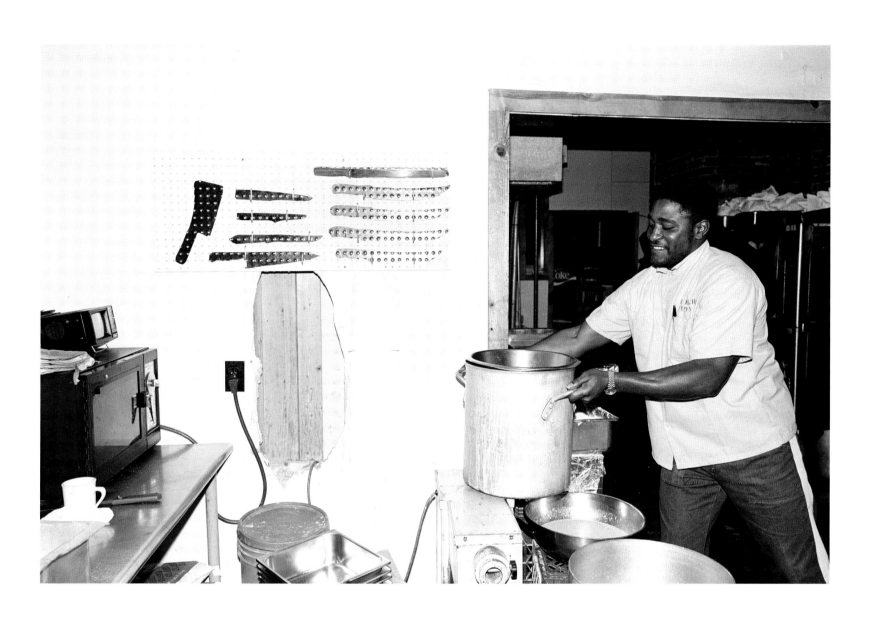

Leake Harris on the job.

was six trips made by me in one year.
Later I found out that you could make
more money with guns. This only lasted
for six months. A year later, I was
back in the same spot. No money. The
idea of robbing a bank came one night
when I didn't have enough money to
buy gas for my car. So I tried it
and fell and when to jail. Now the
story that I had heard about prison
had me about to lose my mind. I was
told that I was going to be raped by
the convicts and beaten the the officers.
I wasn't going to have that. So placed
in my mind that I was going to be
the badest person they would ever
meet. Not long after I got to prison
so older men pulled me aside and talked
to me. They told me that the idea that
I had about prison was all mess up.
They took time each day to show me that

there was a better way to life in and out of prison. Soon I being using prison to learn the tools I needed to be successful in life. I can rember one of them telling me that this place was like an university. One day you will get out (graduate) and you will have the skill for life. Be it good or bad. Now I'm not saying everybody that comes to prison gets out and do better. There are some that refuses to try to do the right thing. I see myself as being blessed. I know that I can do the things it takes to be the man I want to be.

Lex...

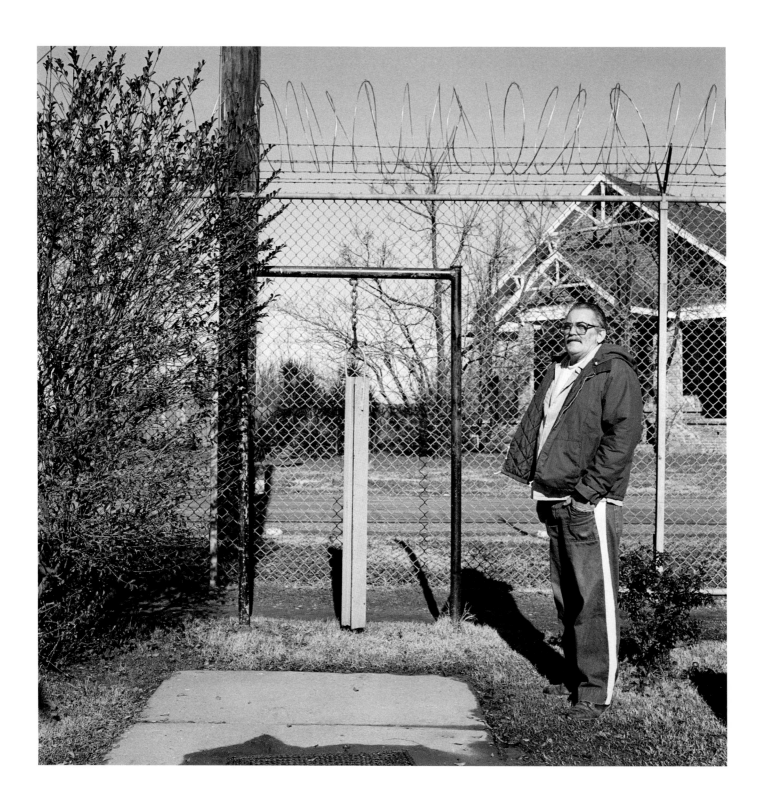

116 Roger Fairchild with bell.

Hello Kim

Well you ask me
to write So here it is
my name is Roger Fairchild
48111 unit 10 parchman, ms.
38738. I am 55 years young
I have been here for 13
years now. For something
I did no do. I just
happen to be in the
wrong place at the wrong
time, the man who did
the crime was released
by the ex governor Ray
mafus four years ago.

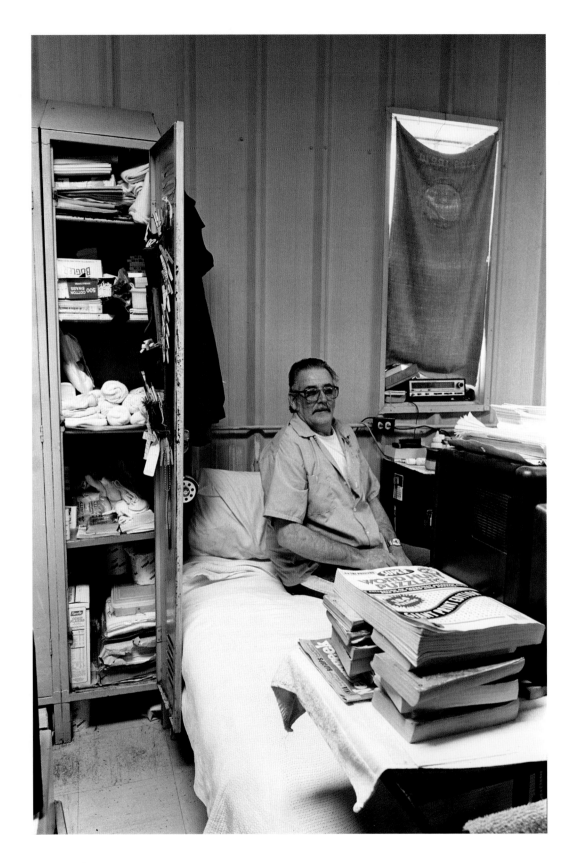

118 Roger Fairchild in personal space.

You ask about how Prison life is for me. Well it's not my choice But if you do as you are told and lit the booze and drug's alone and mine your own p&Q. It's not to bad at least you don't have to worry about your back. Prison life is a lot like the military of you follow what I mean. I was born and raised in Pennsylvina where d plan on going back to if they let me go for one reason or another. As I have family and friends there

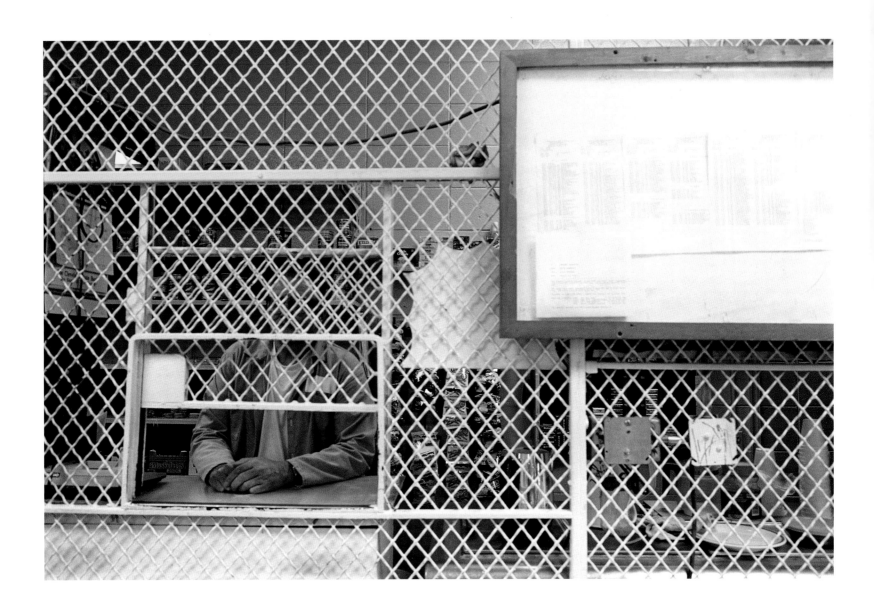

120 Roger Fairchild on the job.

who want me back
home. well I guess
that's about all there
is for now.

take care and
God Bless.

Roger Fairchild
48111 unit 10
Parchman, ms.
38738

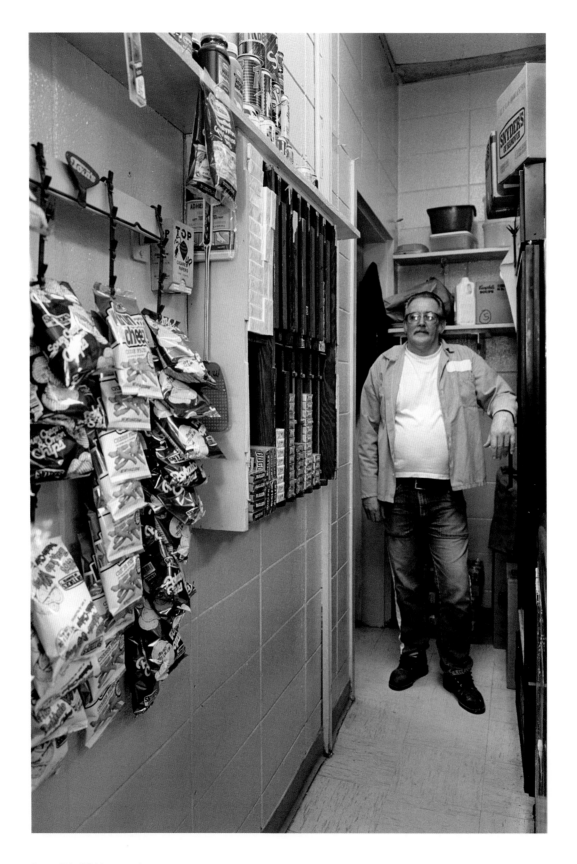

122 Roger Fairchild in commissary.

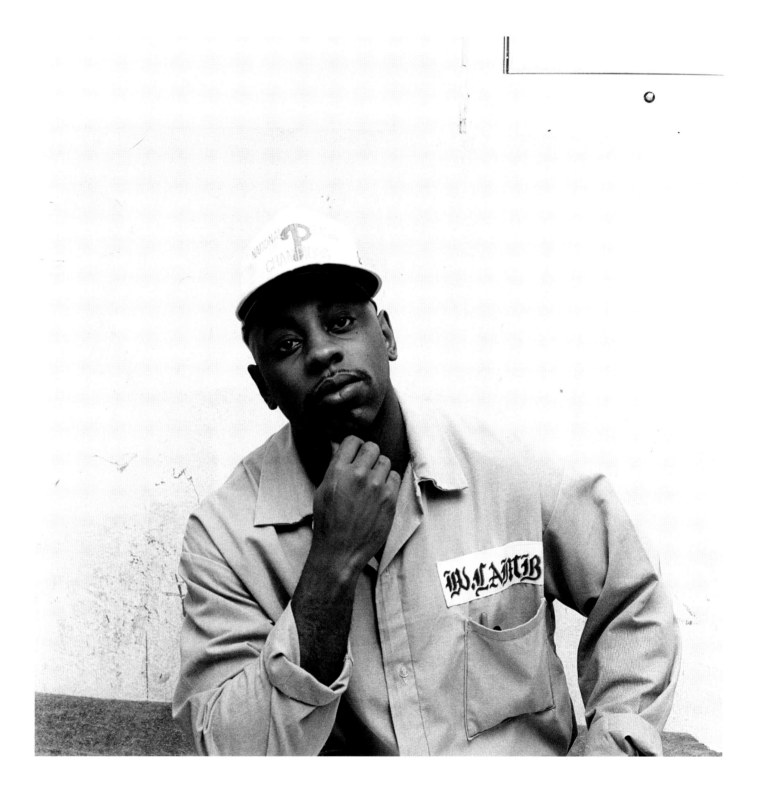

I like to look at, and compare my stay in Parchman as being similar to the process that turns a regular, worthless piece of coal into a priceless diamond. It takes time and lots of pressure to turn a piece of coal into a diamond, and it takes time and pressure to make a person strive to reach a higher level in the game of life. But before I explain this point of view better, I want to say that not everyone in Parchman is an animal or "scum" as some people try to lable us. I came from a good home, was raised with lots of morals and values, and even served in the Armed Forces.

But through it all I was a product of a system, to which I was blind of the facts, that make up the big picture. So I performed like a piece of coal... I was dark (inside) and thought it was me against the world. No one saw any value in me because I bucked the system, and tried to live a dream I had no business trying to live. But now that I have had time to review my past actions, and because of the pressure of living in prison... I feel I will be released from here, and outshine the adverage person. I will be a priceless asset to my family, community, and friends because of the ammount of knowledge I have gained here. Before I come to Parchman no one could look at me for more than (20) seconds, or I took it as an inventation to fight. But the daily pressure of being disrespected by some men, and degraded by all (most) of the staff here, has taught me to control & re route my anger. Upon my release there is nothing that can bring me back to a place where I'm working for nothing, can't even get (1) minutes peace of mind, am looked down on, and I live under constant pressure. There are no shag carpets here, you either work or go to the hole, and there sure isn't any cable T.V. They over exagerate the gong problem a little, but if you are a weak person (Physically or Mentally) you will be preyed on by gongs. There are men that need to be here, and some satisfied with this

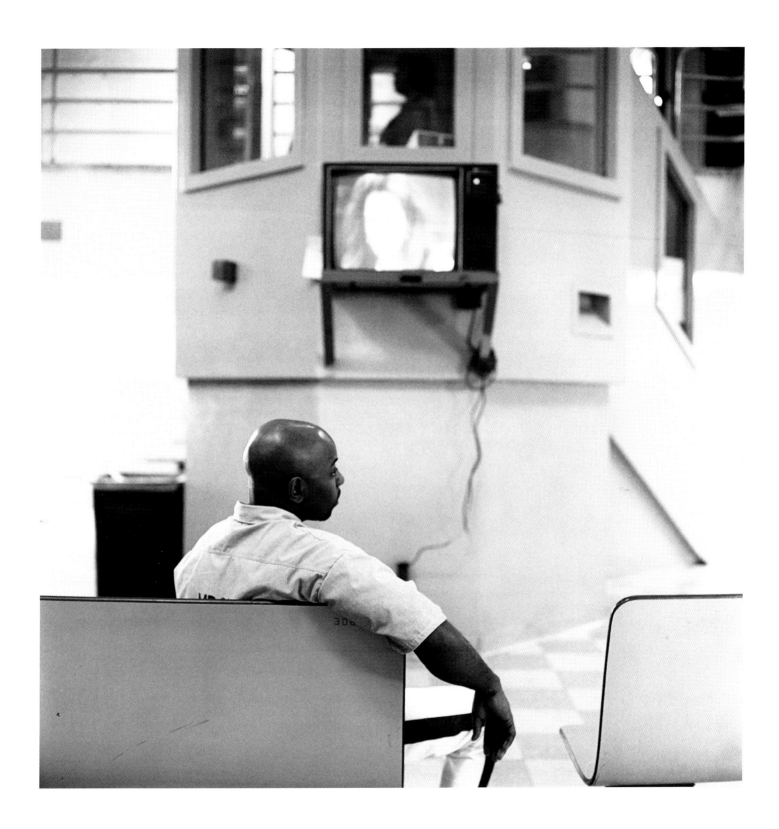

Willie Lamb III with TV.

enviroment. But there are also men that realize where they went wrong, who strive to change and to gain knowledge, and who are no longer blind by the ways of society. And it's these men (men not boys) such as myself who will be something more than a number in a prison. Actually I'm already more free ~~than~~ than alot of people in society. I know who I really am, where I have really been, and where I am really going in this life time.

I also want to add that it is up to the individule to strive for a change.

This is the Mississippi Department Of Corrections, but they do nothing to contribute to my rehibilitation. It's because of my family in Pennsylvania, and my belife in an Almighty Creator that I continue to strive & prosper in the Belly Of Beast. ... I've taken a negative situation and made it work to my advantage.

#80470

Willie Lamb III

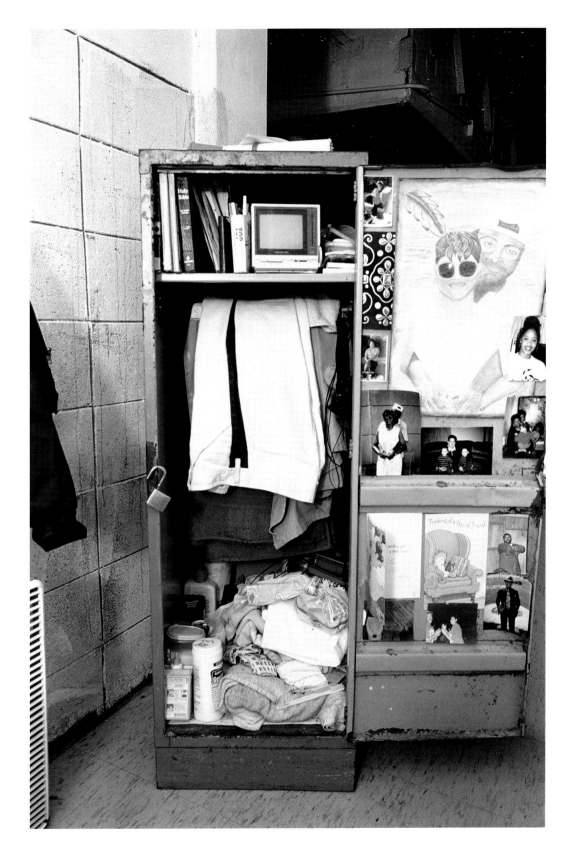

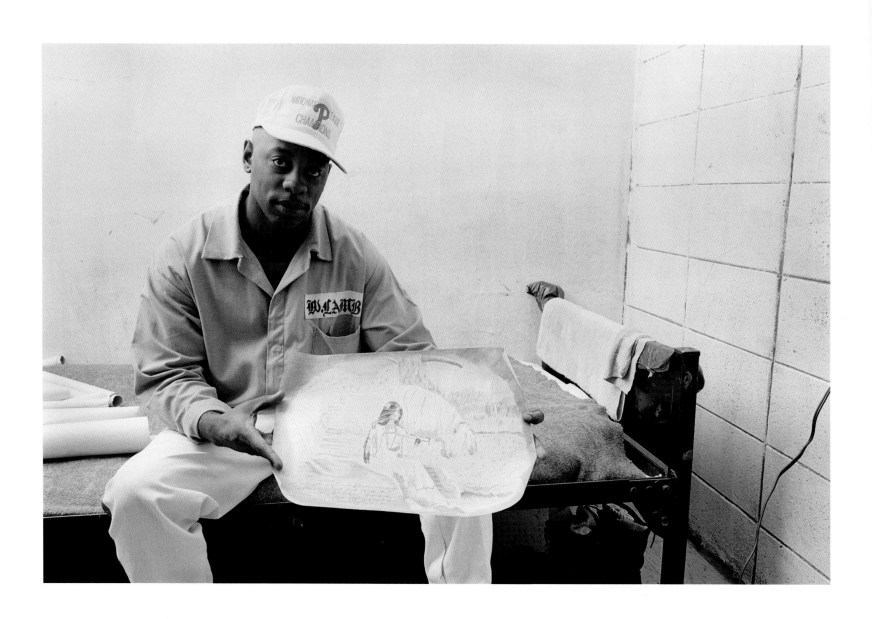

128 Willie Lamb with his art.

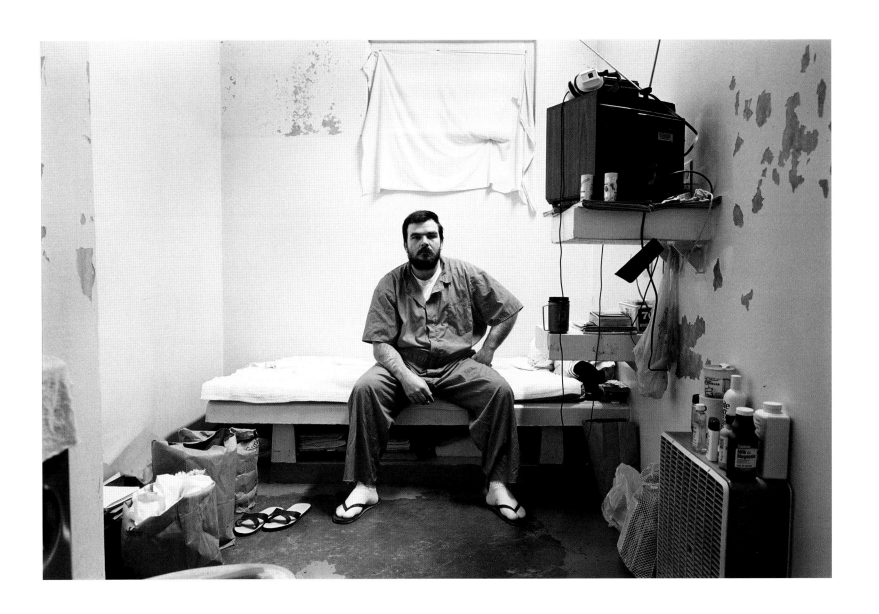

Dear Kim,

Here are the rules that go along with the paper, envelopes and stamps that you asked about.

No more than 10 sheets OF PAPER IN ANY letter

No more than 10 ENvelopes IN ANY letter

No more than 1 BOOK OF STAMPS IN ANY letter, they hAVE to be IN BOOK Form! CAN Not Be Loose Loose, they hAVE to be IN A BOOK From Post-OFFice.

What do I Day night Dream About?

#1 I had just became a father when they lecked me up, and I have never heard my baby girl call me Daddy, it would be music to my ears to hear her come to me and say "Daddy shew me here to do this or that" or Daddy, I need this or that. It is something I will never get, but it is never far from my mind.

I also dream about being there for her first birthday, her first steps, first day of school and so on and so on!!

#2 I dream of my family coming together for me, they all know I didn't do the crime, But due to the way they aren't there for me, you might get the idea that they thought I had done the crime. To be there in time of need, and when you think or know what we are allowed up in here, it wouldn't take a hole lot to be there when I needed them.

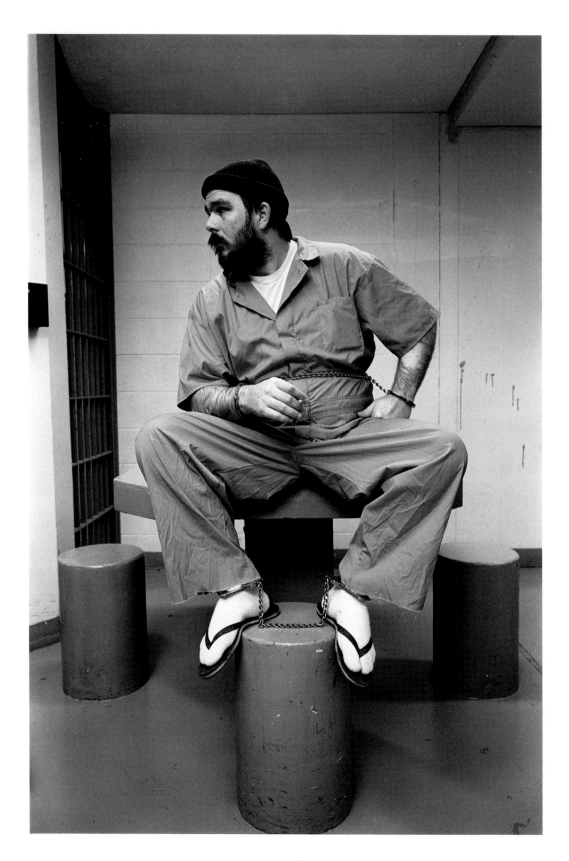

132 Bobbie Wilcher in chains.

#3) of turning the clock back, so that I could
fix a lot of things that were messed up, to
make it better for a lot of the people I love so
dearly.

#4) I dream of going back in time knowing all
that I knew now and instead of being stupid
and letting them charge me with the
crime, I could have said what happen and
this would have never been the way my
life turned out. Some one else would have
been on the row, But

#5) I Dream of the person who did the
crime coming forward for any number
of reasons and setting me free to start my
life over!

#6) (NOT DREAM) but I think about how we
are treated in here, and how we treat
one another, if we would put a small
effort into it, we could get along together
and get out of this place and get on
with our lives, But it is like a race to
see who can be the baddest or to get the
most extra time to add to the time
we had when we first got here!

These are only small looks at what I
dream about, if you would give me a little
feed back on it and send this sheet of Paper
back so I will know what I have already
said, I will write more if this is along the
lines you want. and this is only a start
for there is much more to talk about. Later
 Bobby

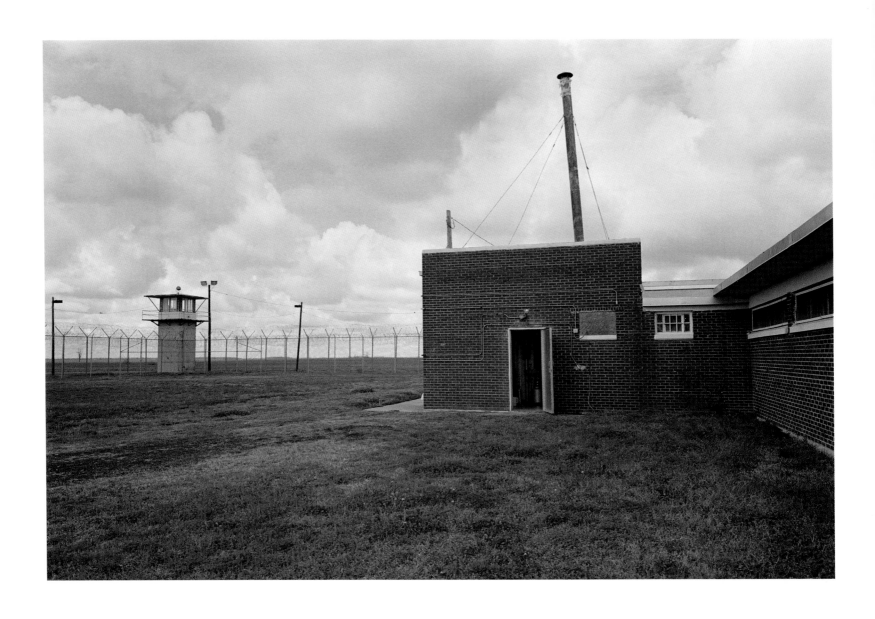

134 Gas chamber exhaust pipe.

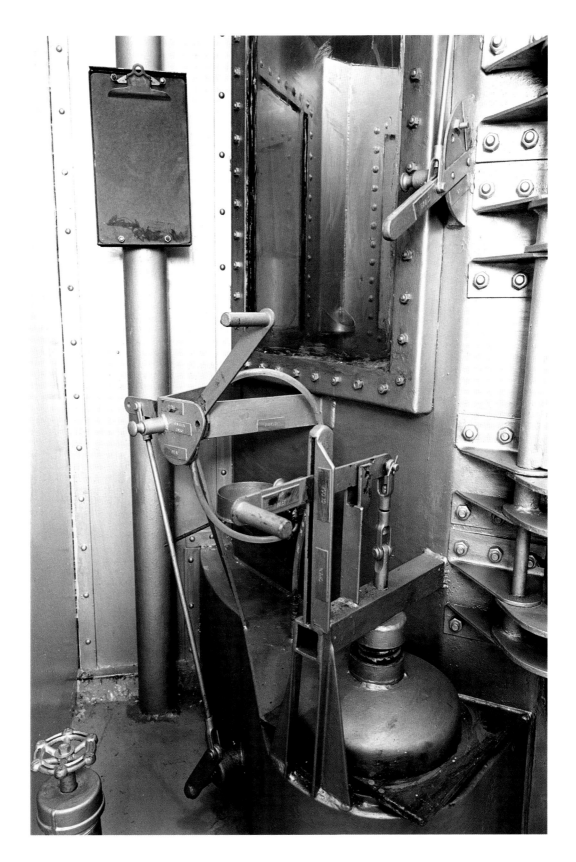

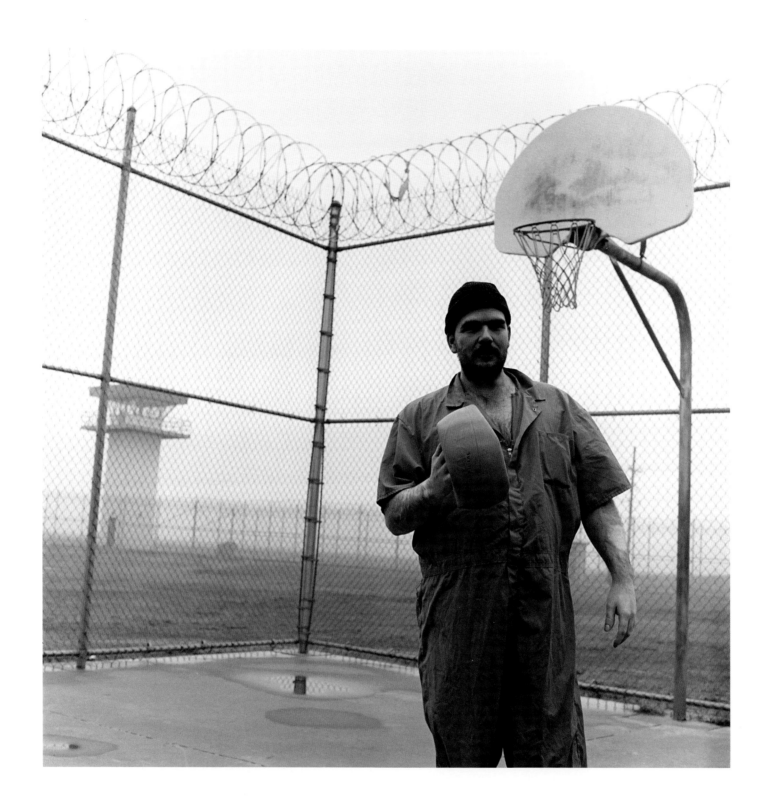

136 Bobbie Wilcher on basketball court.

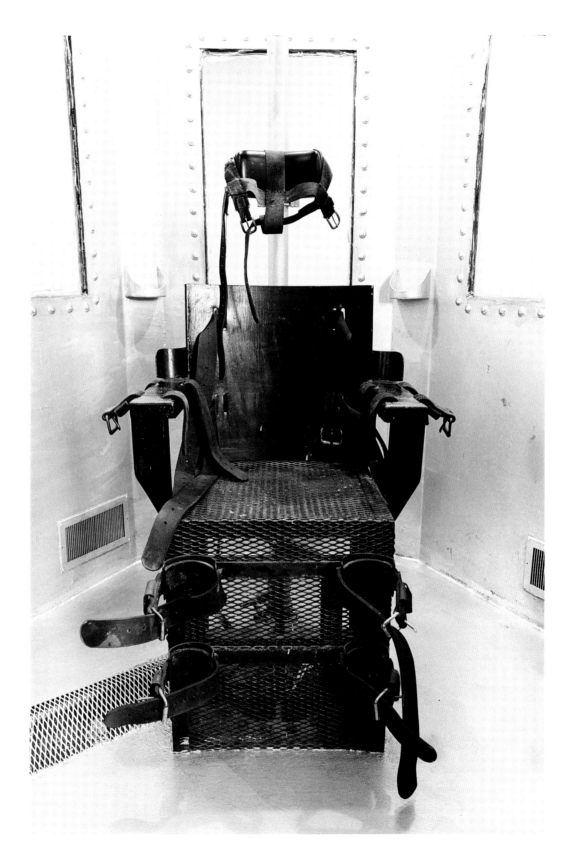

Gas chamber chair. **137**

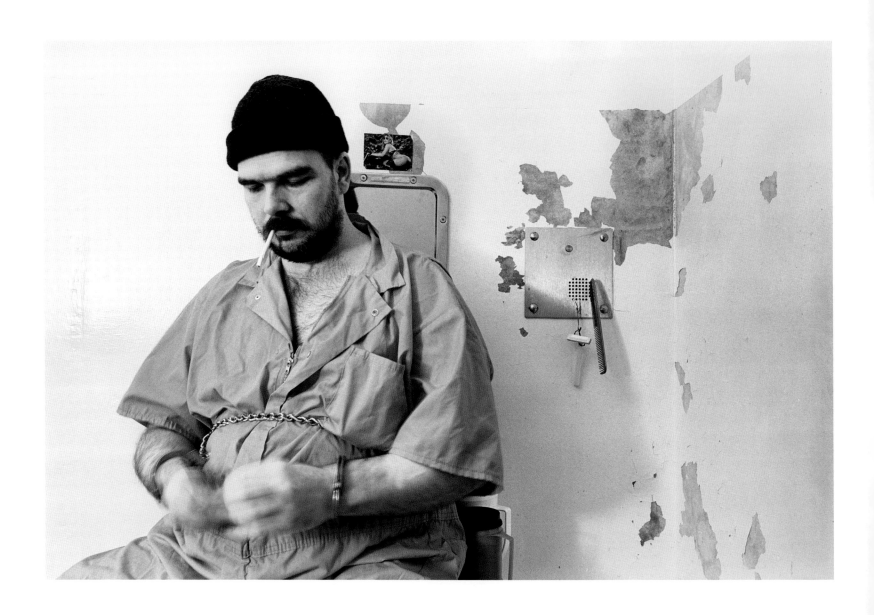

138 Bobby Wilcher smoking.